IMAGES
of America

BLACK ARTISTS
IN OAKLAND

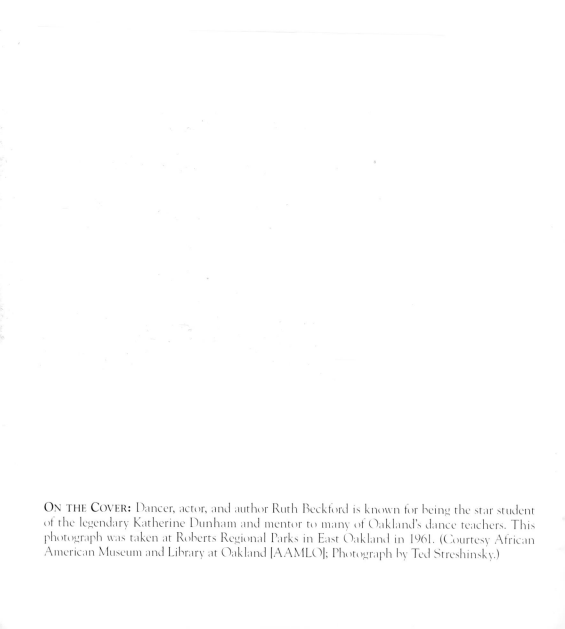

IMAGES
of America

BLACK ARTISTS
IN OAKLAND

Jerry Thompson and Duane Deterville

ARCADIA
PUBLISHING

Published by Arcadia Publishing
Charleston, South Carolina

Printed in the United States of America

Library of Congress Catalog Card Number: 2006938515

For all general information contact Arcadia Publishing at:
Telephone 843-853-2070
Fax 843-853-0044
E-mail sales@arcadiapublishing.com
For customer service and orders:
Toll-Free 1-888-313-2665

Visit us on the Internet at www.arcadiapublishing.com

We dedicate this book to our ancestors, the pioneers of blues and jazz in
Oakland, our mothers and fathers, and to the memory of June Pointer,
one of the original home girls from Oakland. Also to the memory of the
Nubian master musician Hamza El Din.

CONTENTS

Acknowledgments 6

Introduction 7

1. Where the Train Stopped, Oakland Blues Began 9

2. Tell Me How Long the Trains Been Gone 27

3. The Meeting of Great Writers at the Station 53

4. Lift Your Heart, Kick up Your Feet, Create Art,
 and Live Forever! 71

5. The Home of African Diasporic Artists 101

Afterword: The Contemporary Scene 125

Bibliography 126

Index 127

ACKNOWLEDGMENTS

We would like to thank photographers Kamau Amen-Ra and Kathy Sloane for their great contribution of original, previously unpublished photographs. We would like to give a deep thanks to Hannah Clayborn for switching on the light of this project. Thanks to photographer Mastahn Fanaka, Art Sato, Jerri Lange, Horace Mansfield, and Ron Carson for contributing oral histories about Oakland's artists and performing spaces. We'd also like to thank Kim, Shannon, Rick Moss, and Veda at the African American Museum and Library for their support. Thanks to Patrice Hidu of the Oakland East Bay Symphony and to our gracious hosts Lashawn and Ruby at Esther's Orbit Room; we also have to thank Paul for sending those wonderful shots of the Pointer Sisters. Among our fellow Arcadia authors, we'd like to give some props to Analee Allen for her guidance and experience. Also we'd like to thank our editor, John Poultney, for coming on to the project with all of his enthusiasm for Oakland's music scene. Thanks to our Pointer Sister connection and Bay Area singer Brenda Davis (who don't you know, lady friend?). Thanks also to Adeeba Deterville, always on time with the encouragement and inspirations that we needed at times. We are grateful to all the photographers who joined us on this artistic journey.

INTRODUCTION

Black Artists in Oakland is a book with eyes, hands, and feet with painted toes—and with whispers dangling around its neck. It's a roll call of the drummers who planted the songs of life in the patches of land claimed by the first African American families who sojourned across the Great Plains to the gardens of West Oakland and to Seventh Street, where the train stopped.

When we proposed the idea of this book, we were kneeling on one knee before the ancestors of hymns and dreams blown across the San Francisco Bay. We were pushing back the landscape of eyes eager once again to blaze a trail, to inspire the young, and to pay homage to a place built on staring down adversity through music and word and of a collective black consciousness discovered and rediscovered through the carefully orchestrated, sometimes jazz-infused pages that follow.

We realized during those initial conversations and visits with luminaries such as Reginald Lockett and Daphne Muse that the history of black artists in Oakland was going to be more then a gathering of photographs. For us, it meant allowing the dots to be connected between us, brushing off the years of unacknowledged talent and casting an eye on those who helped blaze the trail.

Black Artists in Oakland is a kiss from a thesaurus of artistic moments spilling through the talents of writers, poets, musicians, and artists who have seduced the landscape of brilliance between them—every poem a family, every canvas a neighborhood, every composition an embrace from the ancestral inheritance spreading, encouraging, and breathing life into the next generation.

Every black artist knows where they were the night Oakland said "yes" to defining place and soul in their given artistic aesthetic. I was in Trenton, New Jersey, and the year was 1973. *That's A Plenty* had just been released by the Pointer Sisters—still a quartet then—and in my 12-year-old mind, they were the most electrifying black women I had ever seen in my life, or in music. I was young, but I knew what I needed from the energy around me, and I knew right around the second time I put that album on the turntable that I *had* to get to Oakland.

I traveled across the states for a couple of years on Greyhound meeting people who were also chasing after the same dreams I was—the dream of becoming a writer like Langston Hughes, or of loving all the wrong people at the right time. I was chasing after the epicenter of being black, soulful, and creatively ignited. We scribbled in our journals and sketch pads all day, for that was the way we had conversations with our dreams.

The Pointer Sisters' "bay-flavored" lyrics and the very mention of "Oakland" possessed me and inspired me. I began to long for the place I now call home. I was reminded by the recent passing of June Pointer that the book in your hands would find its trueness by capturing the journey any artist takes to seek out his or her most authentic voice. Behind the images are the stories, paths or roads we have used to get to the artistic center of Oakland, and here we are quick to reassemble our sense of home, to rekindle our sense of urgency for expression of self, and to celebrate an ongoing black arts movement.

It is this conversation of what could be done—what *can* be done when all of the dots are connected—that allows what we've created in these pages to breath deeply and freely at last. We

hope that the reader will discover through these pages an Oakland that serves as a creative home for many artists. Discover the energy and wisdom of writers like J. California Cooper, Danyel Smith, Opal Palmer Adisa, Ishmael Reed, Reginald Lockett, and Alice Walker; of artists like the king of cool, Woody Johnson, Arthur Monroe, and Raymond Saunders; and of musicians like Ronnie Stewart and Prince Lasha, all of whom have made their mark and continue to inspire the younger generations. We've come a long way not to say hello to the moon. Not once will the gods and ghosts dream the same dream, but they will look back and ask the young man why Tupac must live in the minds of his generation. Oh we've come a long way not to say hello to the moon and wish it were a lover.

I was coming home to Oakland like so many before me, like so many after me.

—Jerry Thompson

One

WHERE THE TRAIN STOPPED, OAKLAND BLUES BEGAN

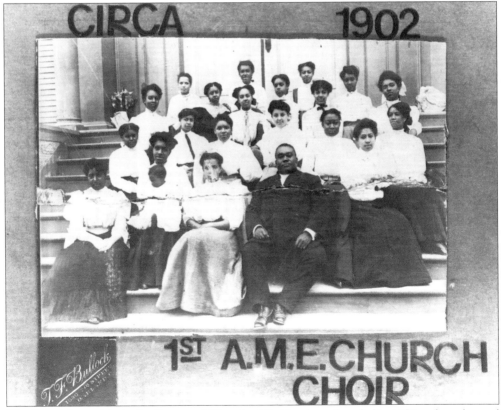

The First African Methodist Episcopal Church of Oakland was founded in 1858 and was located at Seventh and West Streets in West Oakland. This rare photograph, taken in 1902, is of the first AME choir. (Courtesy Oakland History Room.)

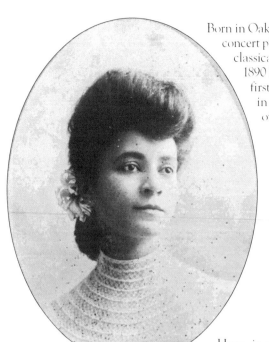

Born in Oakland in 1876, Pauline Powell was a painter and concert pianist; her memorized recitals were of European classical music. Powell's paintings were shown at the 1890 Mechanics Institute Fair in San Francisco. The first black artist to have her paintings exhibited in California, Powell died in Oakland in 1912 of tuberculosis. (Courtesy AAMLO.)

Here is a still-life painting by Pauline Powell. (Courtesy AAMLO.)

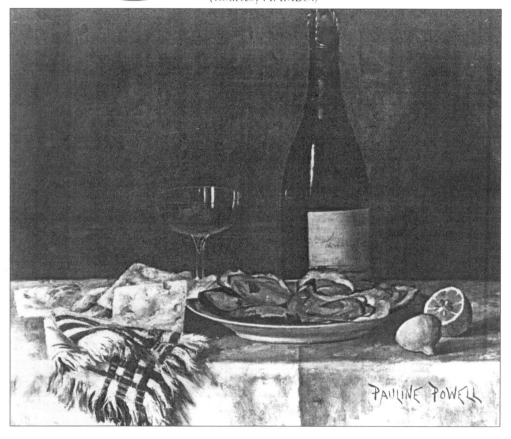

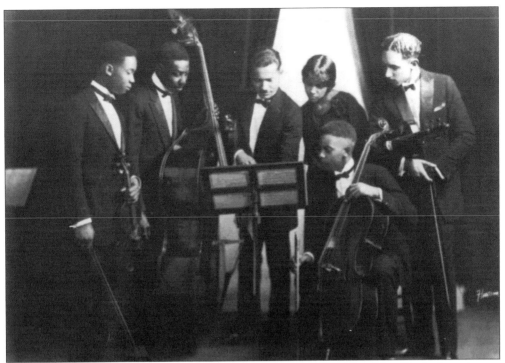

The Oakland String Sextet, shown around 1948, was led by Earl Grandison. (Courtesy AAMLO.)

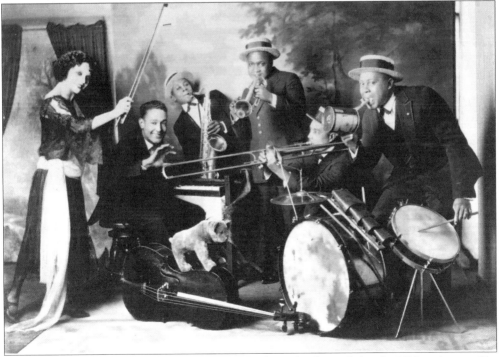

Oakland-born pianist and entertainer Henry Starr performed and recorded in the 1920s with artists like drummer Curtis Mosby, who was another early Oakland jazz musician. (Courtesy AAMLO.)

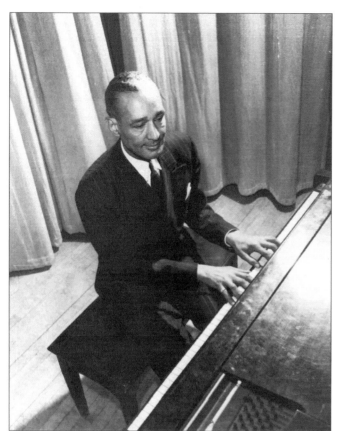

In 1929, Henry Starr appeared regularly on the Edna Fischer Show, becoming the first black entertainer to star on a radio show in San Francisco. He accomplished this in an age when American apartheid (in the form of segregation) and Jim Crow laws prevented black entertainers from being hired. (Courtesy AAMLO.)

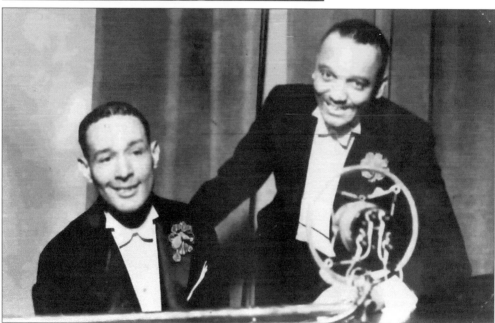

Henry Starr (left) is pictured with an unknown performer. He recorded on the Flexo label in 1928 and in England in the mid-1930s.

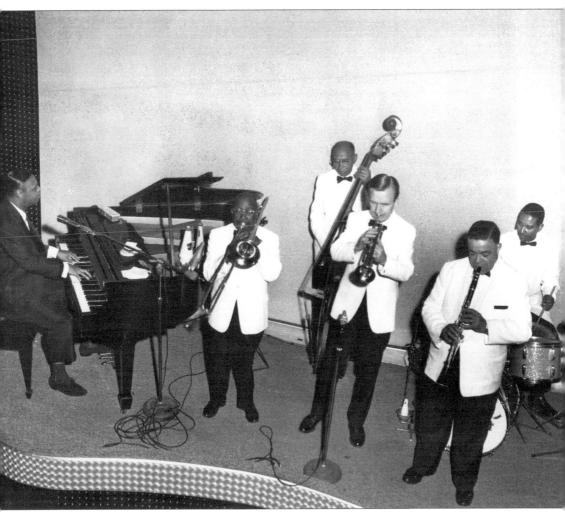

Jazz legend Earl "Fatha" Hines (piano) is seen in performance with Jimmie Archie (trombone), Pops Foster (bass), unidentified (trumpet), unidentified (clarinet), and Earl Watkins (drums). (Courtesy Earl Watkins.)

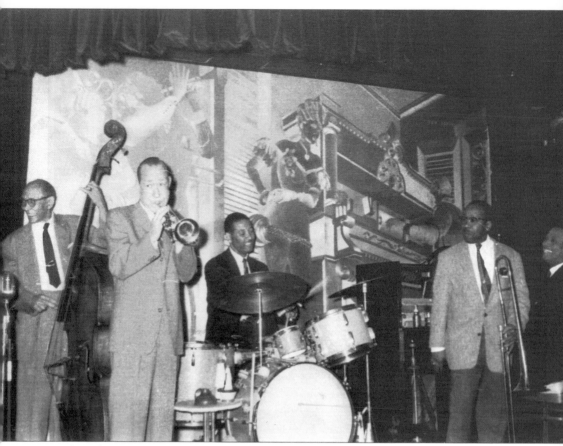

Jazz legend Earl "Fatha" Hines (piano) is seen in performance with Jimmy Archie (trombone), Pops Foster (bass), an unidentified trumpet player, and Earl Watkins (drums). (Courtesy of Earl Watkins.)

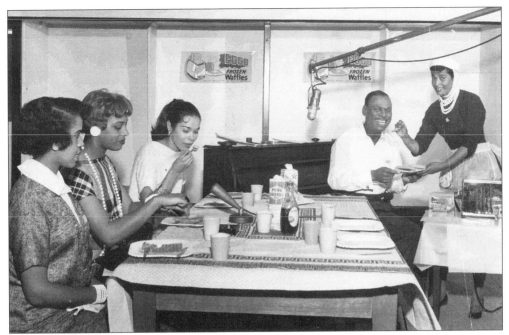

This photograph shows the late Oakland resident and jazz legend Earl "Fatha" Hines in a commercial publicity shot for Eggo Frozen Waffles. This photograph was taken in the 1950s. Hines was a resident of Oakland from the early 1960s until his death in 1983. He is buried in a cemetery near Oakland's Mills College Campus. (Courtesy AAMLO.)

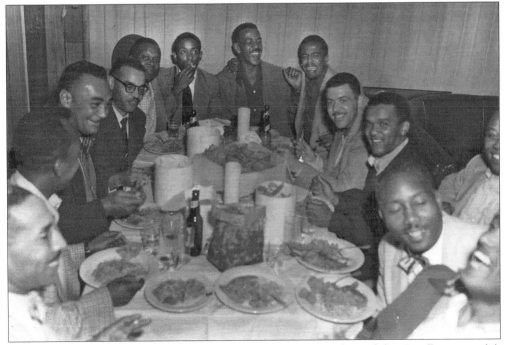

The 1940s saw the rise of several black men's social clubs. Members of this San Francisco club called the Ramblers are enjoying a meal at Slim Jenkins. Slim Jenkins was known for its fine soul food. (Courtesy AAMLO.)

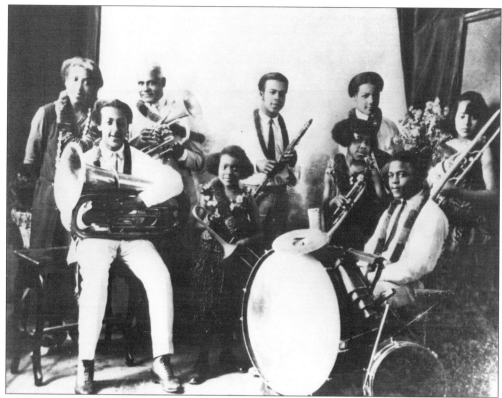

The World Famous Rousseau Family was one of several Oakland ensembles that traveled and performed abroad. These photographs were taken c. 1921. (Courtesy Oakland History Room.)

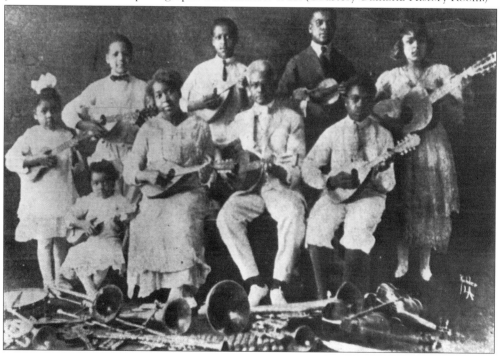

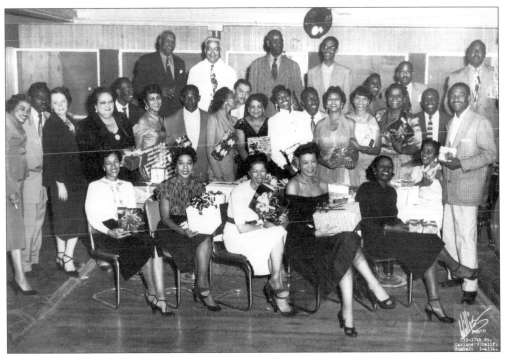

Harold "Slim" Jenkins's nightclub was the center of nightlife in West Oakland in the 1940s and 1950s. Located at the corner of Wood Street between Seventh and Eight Streets, Slim Jenkins hosted live music from all of the prominent jazz and blues men of the era. This famous nightclub opened in 1933 and operated well into the 1960s. Amongst the performers who made appearances were the Ink Spots and Dinah Washington. (Courtesy AAMLO.)

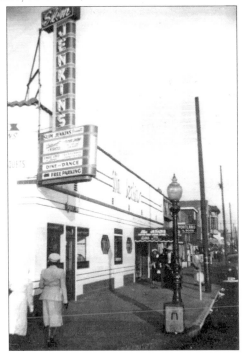

Here is Slim Jenkins's facade in the 1940s. Conveniently, the entrance to the far right was also a liquor store entrance. Later Jenkins sold his liquor license and opened up an entrance in the parking lot to make it easier for his clientele to enter the cocktail lounge and performance room. (Courtesy AAMLO.)

These are some of the well-dressed patrons of the legendary Slim Jenkins nightclub. (Courtesy AAMLO.)

The Continental Club was another well-known West Oakland blues club. This photograph shows some of its patrons in 1949.

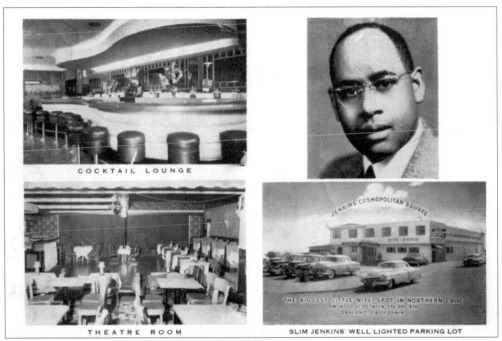

This rare postcard depicts Slim Jenkins and the main rooms of his famous Seventh Street nightspot. (Courtesy AAMLO.)

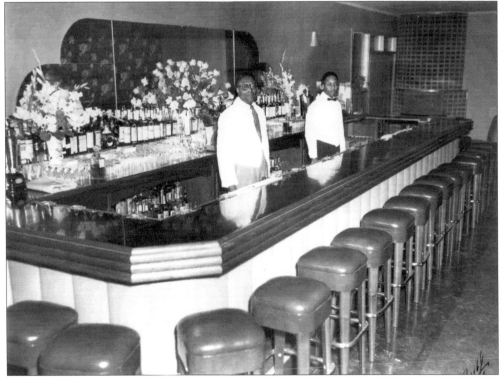

This is a photograph of the cocktail lounge at Slim Jenkins's West Oakland club. (Courtesy AAMLO.)

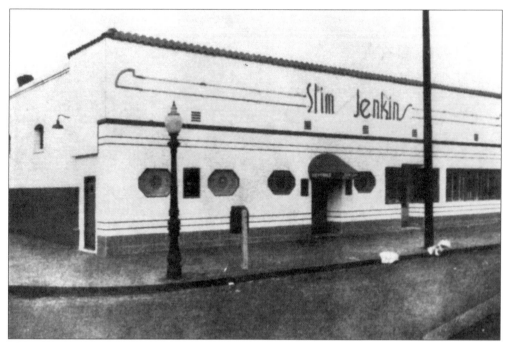

Slim Jenkins's nightspot was located on Wood Street between Seventh and Eighth Streets in West Oakland. It is easily the most famous of the West Oakland blues and jazz clubs and the center of the legendary Seventh Street nightclub scene. (Courtesy AAMLO.)

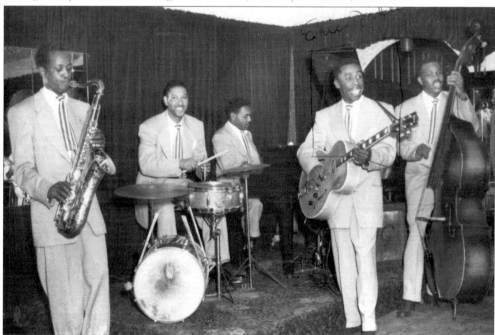

Oakland musician Earl Watkins is shown in this 1951 photograph with the jazz group The Five Nights of Rhythm performing at the Say When Club in San Francisco. The band members, from left to right, are Jimmy Buchanan (saxophone), Earl Watkins (drums), Norvell Randall (piano), Eric Miller (guitar), and Commodore Lark (bass). (Courtesy AAMLO.)

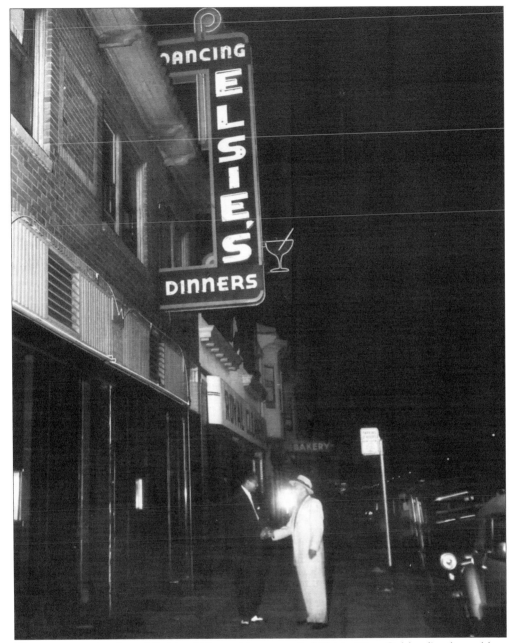

This is yet another famed Oakland blues nightspot called Elsie's. West Oakland's vibrant blues scene was enriched by the presence of these nightclubs. (Courtesy AAMLO.)

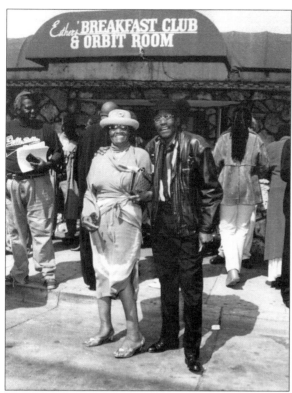

Esther Brown Mabry is the owner of Esther's Orbit Room, which is still in business as of this writing. She started her business along with her husband, William Mabry, in 1960. It began as a breakfast club at a location now occupied by the main post office in West Oakland. The Orbit Room opened in 1963 and featured performances by Al Green, Etta James, and T-Bone Walker, among others. Esther Mabry is pictured here with Jay Payton, who was the first live performer at Esther's Orbit room—along with Big Daddy O Gibson. (Photograph by Joseph Hardy; Courtesy Esther Mabry Collection of Esther's Orbit Room.)

This photograph shows Esther's Orbit Room c. 1987. (Courtesy AAMLO.)

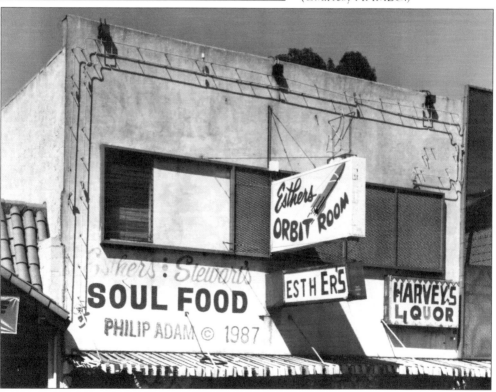

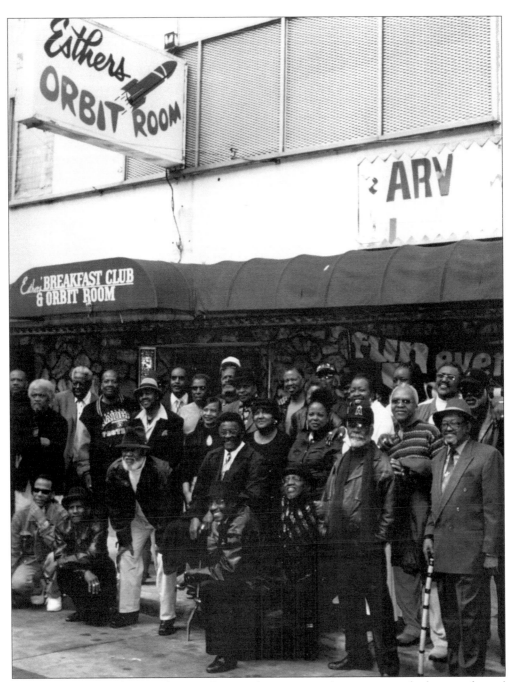

Shown in this 2003 photograph is a gathering of musicians and entertainers who have performed at Esther's Orbit Room. Standing at far left is Oakland writer Ishmael Reed. (Photograph by Joseph Hardy; Courtesy Esther Mabry.)

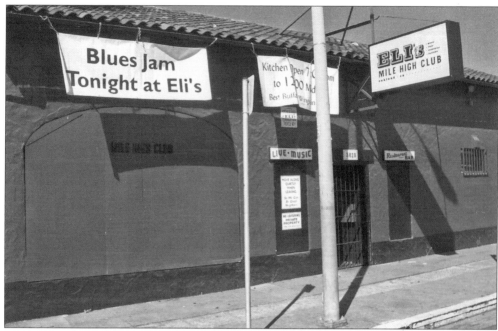

Eli's Mile High Club on Martin Luther King Boulevard has hosted great local blues musicians such as Jimmy McCracklin and Lowell Fulson. It has recently reopened under new ownership and is booking blues music again. (Photograph by Duane Deterville.)

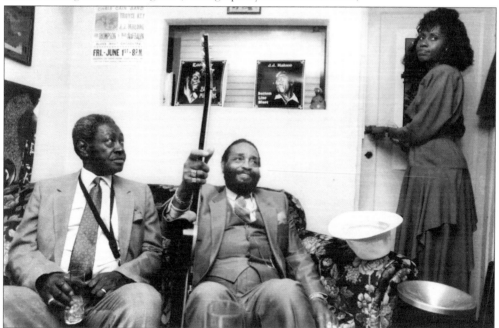

First opened in 1974, Eli's Mile High Club was originally owned by Eli and Alberta Thornton. After several years of hosting local blues luminaries, Eli Thornton was tragically shot to death by a girlfriend in 1978 in his club. Blues musician Troyce Key took over its ownership until his death in 1992. Shown in this photograph are blues musicians C. A. Carr (left) and Lowell Fulson (center) backstage with Margaret Key, Troyce's wife, in 1991. (Courtesy AAMLO.)

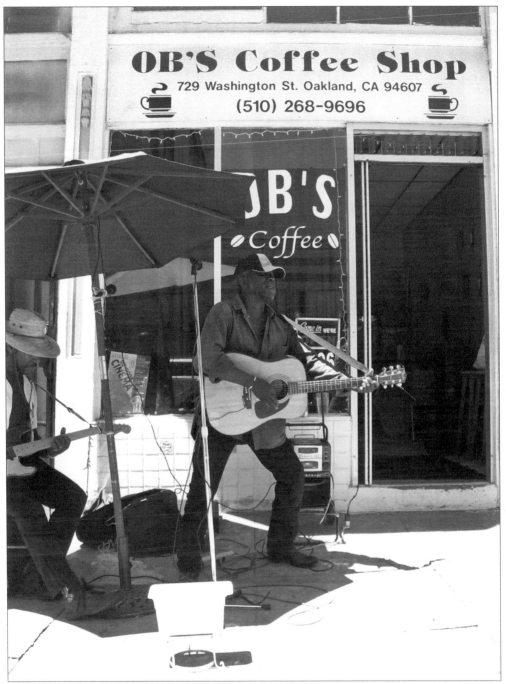

Augusta Lee Collins is shown in this 2006 photograph performing his regular gig every Friday and Saturday from 11:00 a.m. to 2:00 p.m. in front of OB's Coffee Shop in the Old Oakland district. Collins was known as a recording session drummer in the 1970s, performing with Lightning Hopkins and Herbie Hancock and recording with Julian Priester. He currently leads the band M-pulse. This photograph shows M-pulse band member Tony Thibideaux (left). (Photograph by Duane Deterville.)

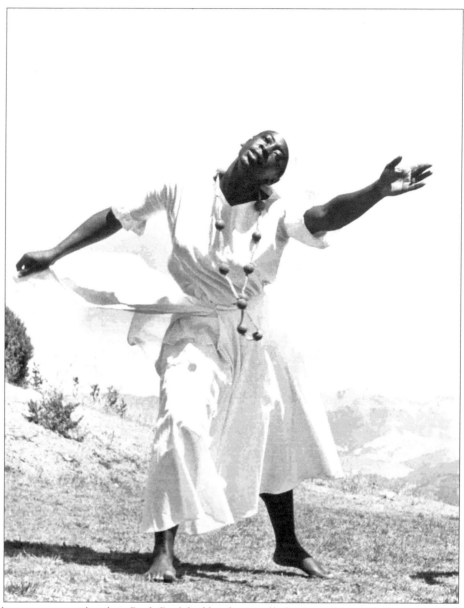

A dancer, actor, and author, Ruth Beckford has been called "Ms. Oakland" for her contributions to the culture and arts of the city. She was born in Oakland in 1925 to parents who were followers of Marcus Garvey. They attended the Universal Negro Improvement Association (U.N.I.A.) meetings in the Jubilee West building that is still standing in West Oakland. Beckford was Katherine Dunham's star student, and in 1953, she taught at the Katherine Dunham School in New York. In 1947, she founded, in Oakland, the first black recreational dance center in the United States. Beckford is the teacher and mentor of many well-known dancers, including the founder of Dimensions Dance Theater, Deborah Vaughn. Nineteen of her students head dance departments or companies across the United States. A highly respected elder, she is called the "godmother" of Oakland's dancers. She says, "I give diva lessons." Beckford is shown in this 1961 photograph taken at Roberts Regional Parks in Oakland just before her retirement performance at U.C. Berkeley. (Courtesy AAMLO; Photograph by Ted Streshinsky.)

Two

TELL ME HOW LONG THE TRAINS BEEN GONE

Mike Henderson is a blues musician, painter, and filmmaker. He has performed at many blues and jazz festivals across the United States and Europe. Henderson is currently an art professor at U.C. Davis. (Photograph by Kathy Sloane.)

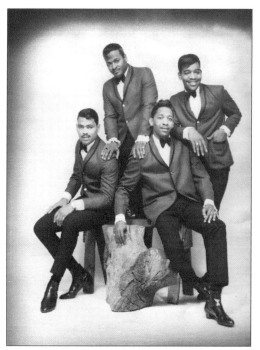

The Fabulous Ballads were formed in 1961. Their first performance was at the Rhumboogie in West Oakland at Twelfth and Peralta Streets on July 4, 1961. This quintessential Oakland soul group can be seen singing the song "Dizzy World," written by group member Rico Thompson, in a nightclub scene for the legendary black film *The Mack*. The group is pictured in this 1963 promotional photograph taken at the Chuck Willis Studio in Oakland. From left to right are John Foster, Rico Thompson, Nathaniel Romerson, and Leslie LaPalmer. They are still touring under the leadership of original group member Rico Thompson. (Courtesy Rico Thompson.)

This promotional photograph of the Fabulous Ballads was taken October 12, 1968, in Los Angeles. Pictured from left to right are Rico Thompson, Nathaniel Romerson, John Foster, and Leslie LaPalmer. (Courtesy Rico Thompson.)

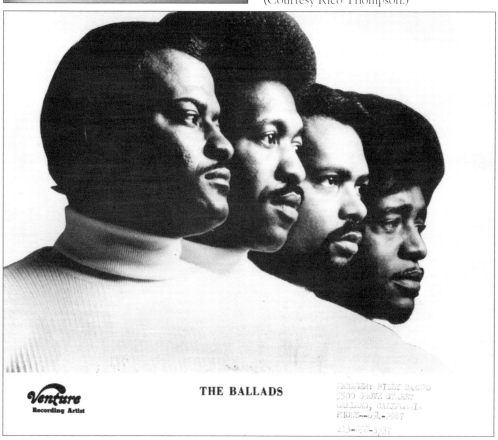

THE BALLADS

Cartoonist Morrie Turner was born in Oakland; his father was a Pullman porter. In 1964, he began pursuing his career as a cartoonist full-time and in 1965 created his trademark comic strip *Wee Pals*, the first nationally syndicated comic to feature African American characters. This rare photograph of Turner was taken in 1964 at the home of *Peanuts* creator Charles Schulz. (Courtesy Morrie Turner.)

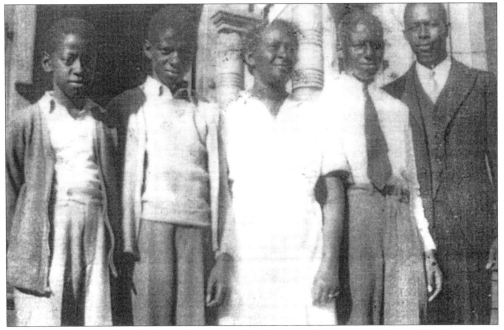

This 1932 photograph of Morrie Turner and family was taken at their home. The house was located at Tenth and Kirkham Streets in West Oakland. From left to right are Morrie, brother Joseph, mother Nora, brother Buster, and brother Edward. (Courtesy Morrie Turner.)

In 1958, the Reverend Dr. W. Hazaiah Williams founded the Four Seasons Concerts and became the first black organizer of a major European classical music series in America. Hazaiah directed the series until his death in 1999, and the memorial concert commemorating his work is still performed at the Scottish Rite Theater in Oakland. This photograph was taken c. 1968. (Courtesy Brenda Davis.)

Here is Morrie Turner in the Oakland Unity Day Parade on St. Patrick's Day riding with the winners of the *Wee Pals* look-alike contest. (Courtesy Morrie Turner.)

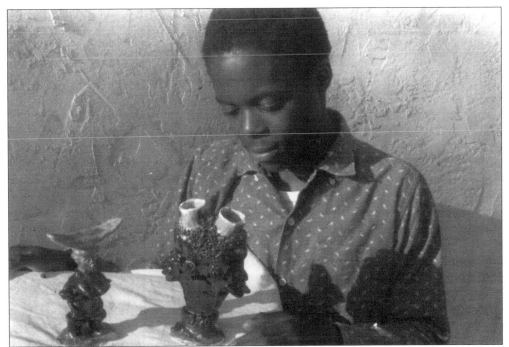

African American master painter Claude Clark Sr. and his family came from Alabama in 1958 to live in Oakland. His son, Claude Lockhart Clark Jr., became an accomplished art educator and sculptor in his own right. Claude Jr. is shown here in 1960 at age 15 with some of his early sculptures. (Photograph by Claude Clark Sr.; Courtesy Claude Lockhart Clark Jr. Collection.)

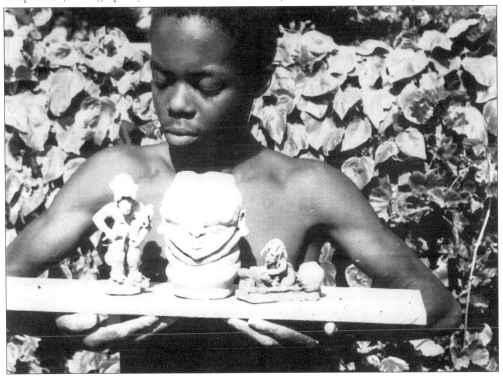

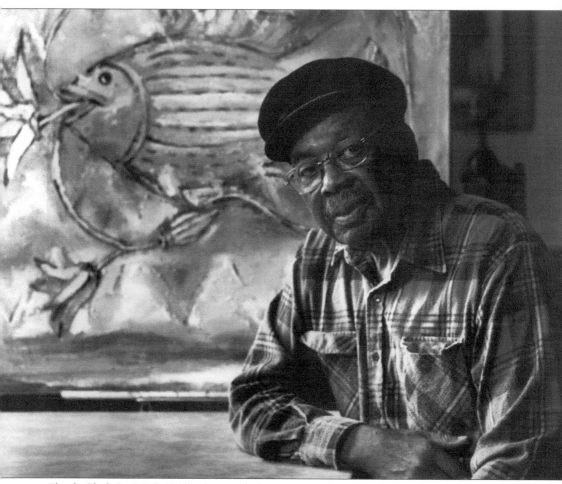

Claude Clark Sr. (1915–2001) is known for his paintings depicting the African diaspora in addition to allegories showing the struggle of black folks in America. His work spans the late 1930s to 1991. He was a professor at Merritt College in Oakland from 1968 to 1981. He is shown here with his last known painting, *The Creative Source*, which was painted in his Oakland studio in 1991. (Photograph by Jonathan Eubanks; Claude Lockhart Clark Jr. Collection.)

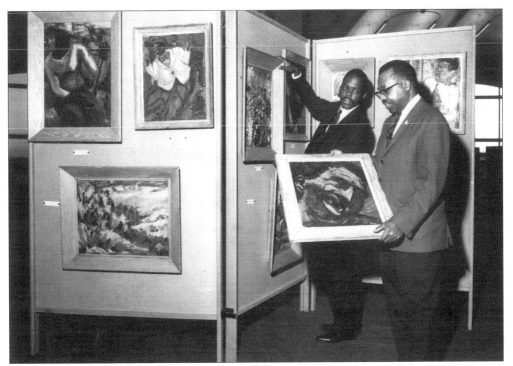

Claude Clark Jr., left, is shown helping his father, Claude Clark Sr., mount paintings for their father-and-son show at Chabot College in 1967. (Courtesy Claude Lockhart Clark Jr. Collection.)

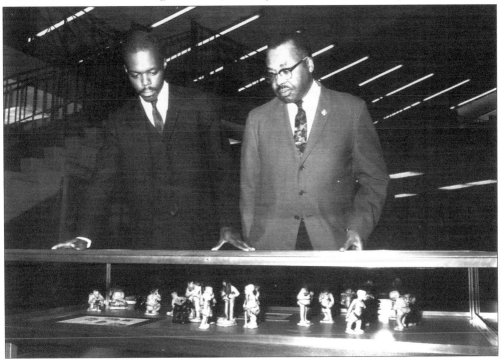

Claude Clark Jr. (left) is shown viewing his sculptures with his father, Claude Clark Sr., at their father-and-son show at Chabot College in 1967. (Courtesy Claude Lockhart Clark Jr. Collection.)

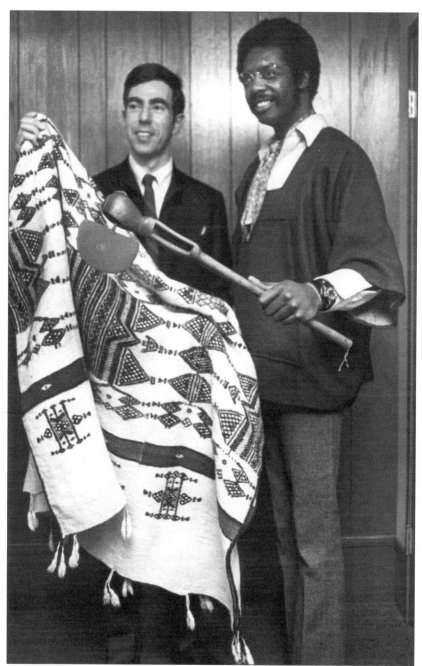

Muralist, painter, and printmaker David Bradford arrived in Oakland in 1969. This early photograph of him was taken at the West Oakland Development Center, where he was the director for several years. He worked on a project to have a traveling museum that would bring artworks from other parts of the world to Oakland's youth. Along with Julia Hare, he was given permission to use artifacts from the Oakland Museum's vast warehouse collection; two of these objects are seen in this photograph. Bradford was part of a generation of black visual artists of the 1960s and 1970s who produced work with social content addressing the critical conditions of black folk in America. He is currently a professor of art at Laney College in Oakland. (Courtesy AAMLO.)

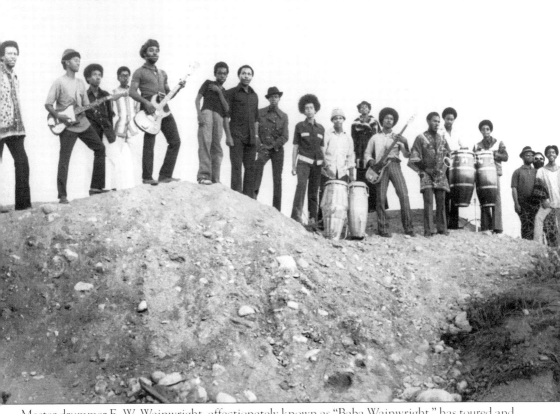

Master drummer E. W. Wainwright, affectionately known as "Baba Wainwright," has toured and recorded with jazz legends Earl "Fatha" Hines, McCoy Tyner, and Pharoah Sanders, amongst others. He is widely respected as an educator and community leader. From 1991 to 2003, he was the director of arts programming at San Quentin State Prison. He is shown here (left) in a rare 1972 photograph in Los Angeles at a ground breaking for the University of Southern California Community Center. Wainwright taught music to the members of the Crips and Brims shown in this photograph. (Courtesy E. W. Wainwright.)

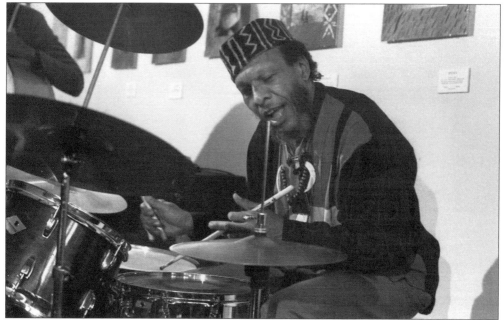

Here E. W. Wainwright is seen performing at the now-defunct gallery and performance space called Khafre's in Old Oakland. (Photograph by Kamau Amen-Ra.)

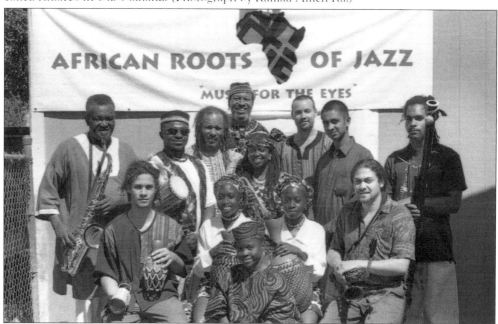

The African Roots of Jazz is a dynamic musical, performing, and educational group founded by master drummer E. W. Wainwright. Pictured here outside their rehearsal space in east Oakland, standing from left to right, are James Carraway (saxophone), Candido Obajami (talking drum), KPFA Broadcast personality Drepemba (not a member of the group), E. W. Wainwright, Phavia Kujichagulia (coleader, trumpet), Liberty Ellman, Vijay Iyer, and Ajayi Lumumba Jackson. Seated from left to right are unidentified (caxixi and shekere), Taiwo, Kehinde, and Eric Crystal (saxophone). The person at front center is unidentified. (Photograph by Kamau Amen-Ra.)

Phavia Kujichagulia is a multidisciplinary artist of the highest caliber. In the West African tradition, artists who preserve history in dance, music, and poetry are known as *griots* (pronounced "greeh-oh") or *djiali* (pronounced "jah-lee"). A multi-instrumentalist musician and dancer, Kujichagulia is a representative of that tradition in Oakland. She has written several volumes of poetry and a book on racism titled *Recognizing and Resolving Racism: A Resource and Reference Guide for Humane Beings*. (Photograph by Kamau Amen-Ra.)

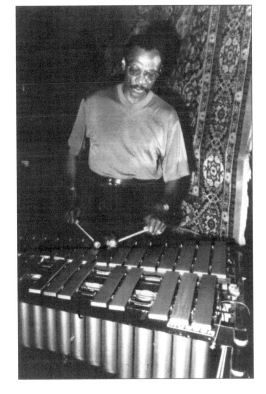

Vibraphonist Yancy Taylor is known for his Sunday night performances at Oakland's popular Fifth Amendment Club, formerly located on Lakeshore Avenue. He performed there every Sunday night for 17 years. Since 1992, Yancy has garnered an international audience by touring France, Holland, and Germany. (Courtesy Yancy Taylor.)

Oakland Trumpeter Rasul Siddik is shown in these early 1980s photograph performing at the Loft on San Pablo Avenue in Oakland. Siddik went on to take up residency in New York and Paris, eventually performing with avant-garde jazz legends Henry Threadgill and David Murray. (Photograph by Kamau Amen-Ra.)

The Front was another alternative jazz space in Oakland. This rare c. 1981 handbill advertises a performance by Rasul Siddik and the Now Artet. (Courtesy Horace Mansfield.)

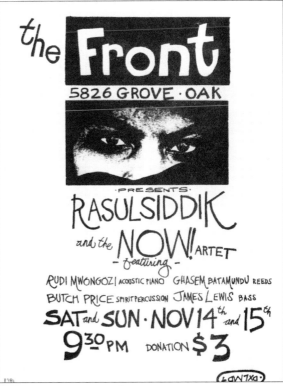

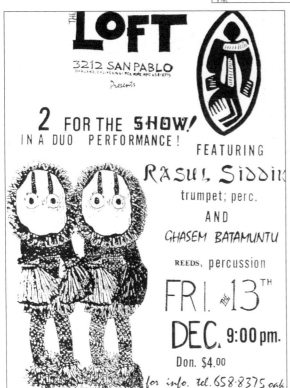

This rare handbill shows an early-1980s duet performance with Rasul Siddik at the Loft, which was an independent black performance space located at 3212 San Pablo Avenue. The space also held classes led by Themba Mashama for capoeira Angola, an African Brazilian martial art/dance. (Courtesy Horace Mansfield.)

39

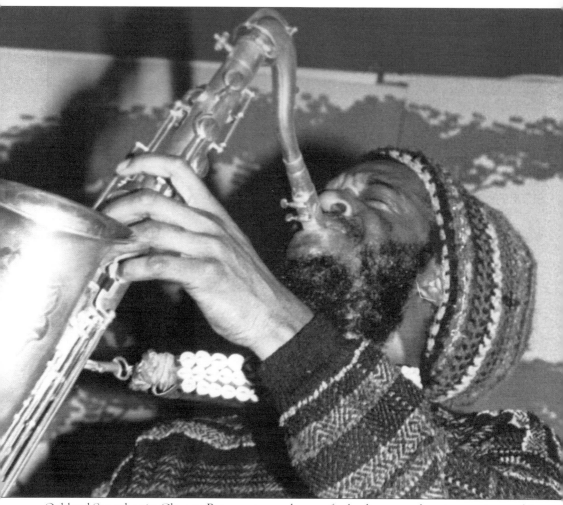

Oakland Saxophonist Ghasem Batamuntu was known for leading marathon jam sessions at his storefront live workspace on Telegraph Avenue in Oakland. A fixture in Oakland's progressive black music scene of the 1980s and early 1990s, Batamuntu performed at the Loft and Koncepts Cultural Gallery, among other East Bay venues. He eventually relocated to Denmark and performed with his group The Nova Ghost Sect-tet. (Photograph by Kamau Amen-Ra.)

Oluyemi (bass clarinet) and Ijeoma Thomas (vocalist) have been performers in the independent galleries and music venues that feature progressive improvisational music for many years. They are widely respected in both the West Coast and East Coast improvisational music scenes. This photograph was taken in the early 1980s at the Loft on San Pablo Avenue. (Photograph by Kamau Amen-Ra.)

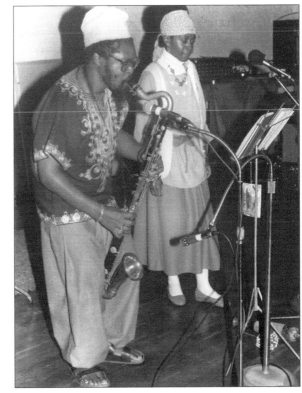

Multi-instrumentalist Oluyemi Thomas and his wife, vocalist and poet Ijeoma, form the core of the explorative music group Positive Knowledge. The drummer Spirit rounds out the group. They have issued five albums since 1995. This photograph was taken in Oakland's Jack London Square. (Photograph by Kamau Amen-Ra.)

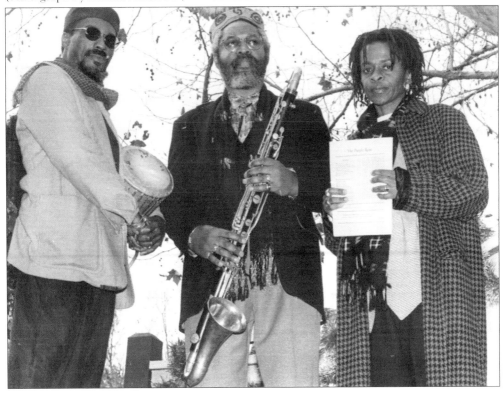

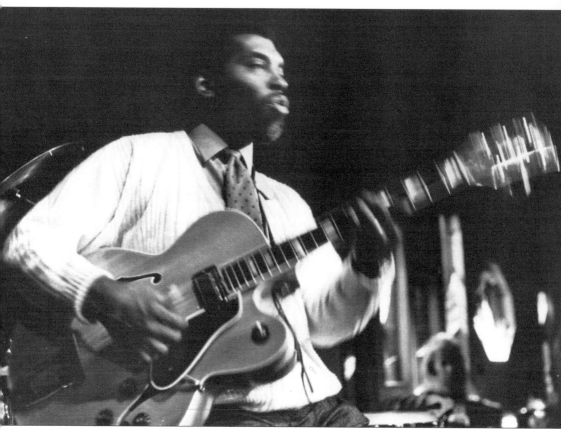

Jazz guitarist Calvin Keys has performed in the working bands of Ray Charles, Ahmad Jamal, and Jimmy Smith, among others. He recorded his first recording, *Shawn Neeq*, on the legendary Black Jazz label in 1971. He is a mainstay in Oakland's jazz scene and is often seen performing with his trio at the Hyatt Regency, Yoshi's, and Q's. (Photograph by Kathy Sloane.)

Pianist Kito Gamble is the daughter of jazz singer Faye Carroll. She worked for many years teaching music in Oakland's school systems. Known as a prodigy, she had her first professional performance at the age of 10 in San Francisco's Great American Music Hall. This photograph was taken at her 21st birthday party performance at the jazz club Yoshi's in 1993. (Photograph by Kamau Amen-Ra.)

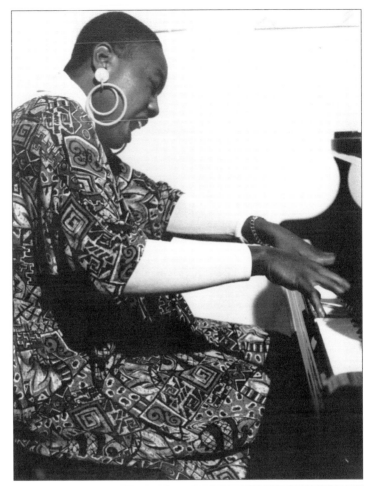

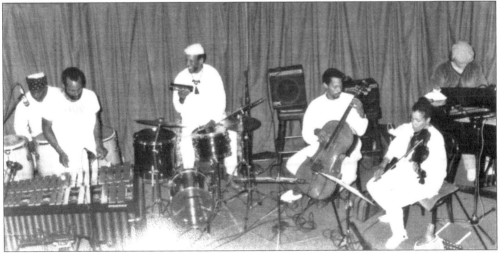

This 1981 photograph shows Killion in performance with, from left right, Ed Polk (percussion), Rickey Kelley (vibes), E. W. Wainwright (drums), Kash Killion (cello), India Cooke (violin), and unidentified (piano). (Courtesy E. W. Wainwright.)

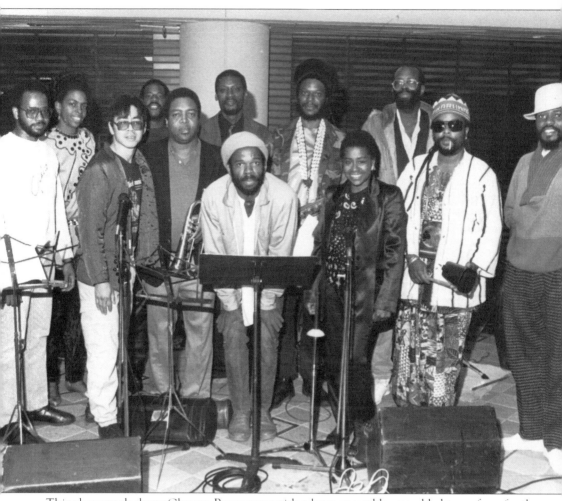

This photograph shows Ghasem Batamuntu with a large ensemble assembled to perform for the city of Oakland's 1983 Summer Arts Series. Pictured from left to right are Brian Kirk, Loraine Hodge, Jon Jang, Anthony James, Oscar Williams (trumpet), James Lewis, Tacuma King, Ghasem Batamuntu (saxophone), Diane Witherspoon, Wayne Wallace, Mosheh Milon, and Rondo Debongo. The performance took place at the Twelfth Street BART train station. (Courtesy Kamau Amen-Ra.)

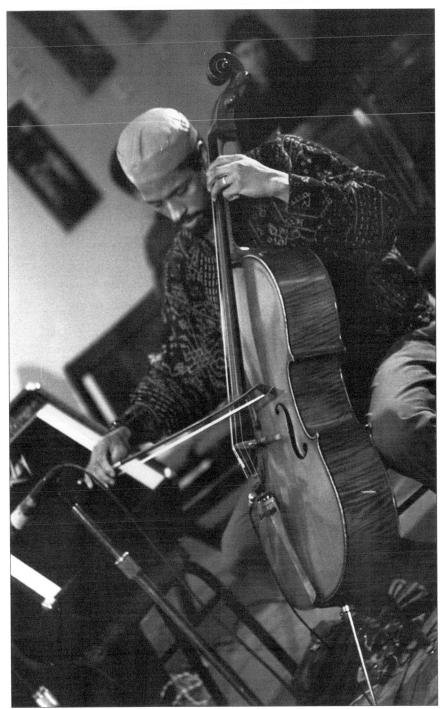

Cellist Kash Killion is a mainstay in Oakland performance spaces. He has performed with many notable international jazz artists, such as Cecil Taylor and Pharoah Saunders. In addition, he has proven to be a fine accompanist to poets such as Amiri Baraka and Quincy Troupe. He is shown here in a performance c. 1990 at Koncepts Cultural Gallery. (Photograph by Kamau Amen-Ra.)

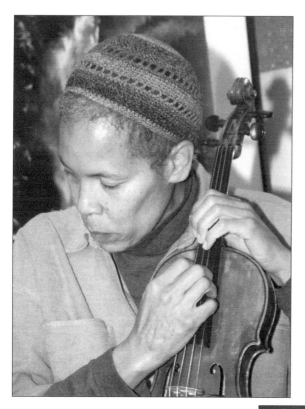

India Cooke is a dynamic violinist/ composer who has performed with Ray Charles, Sarah Vaughn, and Cecil Taylor. Equally as comfortable with European classical music as she is with highly exploratory jazz, Cooke has performed at many Oakland venues and taught music at Oakland's Mills College. This photograph was taken at the Malcolm X Jazz Festival in Oakland. (Photograph by Kamau Amen-Ra.)

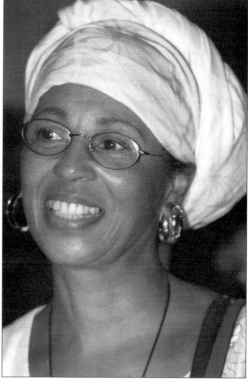

Tarika Lewis is another of Oakland's great violinists. Similar to Pauline Powell, who lived 100 years before her, she is a visual artist as well as a musician. In addition, she is known in the Oakland community as the first woman to join the Black Panther Party. (Photograph by Kamau Amen-Ra.)

Alto saxophone legend John Handy was born in Texas but came to Oakland as a youth in 1948. He attended McClymonds High School and met his longtime collaborator, violinist Michael White, there while a member of the Glee Club. Handy is known for having recorded classic performances with Charles Mingus, a particularly famous live performance of "Spanish Lady" at the 1965 Monterey Jazz Festival, and his 1976 hit recording "Hard Work." This photograph was taken at Oakland's Festival at the Lake. (Photograph by Kamau Amen-Ra.)

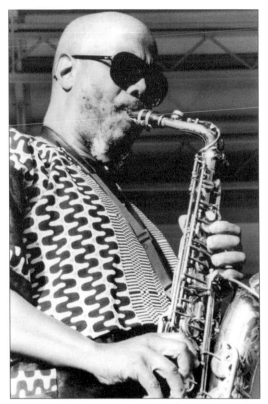

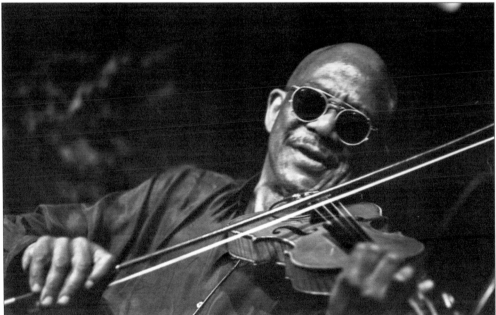

Violinist Michael White is another legend amongst jazz violinists. White grew up in Oakland and attended McClymonds High School in West Oakland. He has recorded and performed with John Handy, Joe Henderson, John Lee Hooker, and McCoy Tyner, among others. (Photograph by Kamau Amen-Ra.)

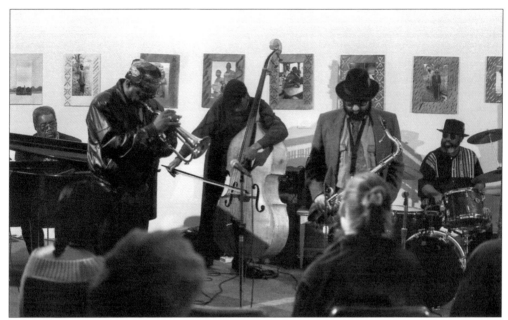

This performance at gallery and performance space Khafre Community Center in the Old Oakland district shows, from left to right, musicians Ed Kelley (piano), Eddie Gale (trumpet), unidentified (bass), unidentified (saxophone), and Kamau Seitu (drums). (Photograph by Kamau Amen-Ra.)

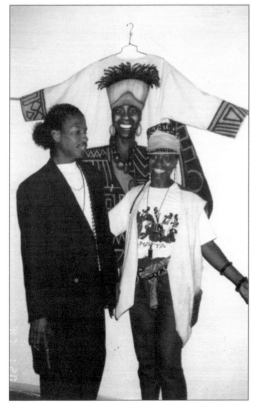

The founder of Khafre Community Center was C. Sade Turnipseed, shown here with Oakland dot Com Gallery founder Randolph Belle.

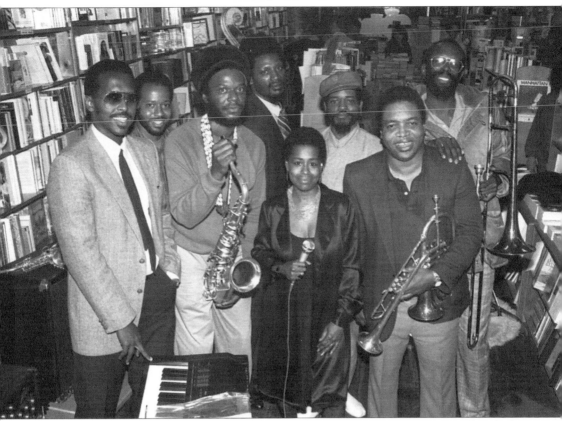

Shown here after a performance are, from left to right, jazz musicians Glenn Pearson, unidentified, Ghasem Batamuntu (saxophone), James Lewis, Diane Witherspoon, Rondo Debongo, Oscar Williams (trumpets), and Wayne Williams. (Photograph by Kamau Amen-Ra.)

Poet, activist, broadcast personality, musician, and photographer Avotcja Jiltonilro has for a long time been a performer in Oakland's cafés and performance spaces. Having performed with jazz legends, such as Rhasaan Roland Kirk and John Handy, she currently leads her own jazz ensemble called Modupe. This photograph is from a performance at the Malcolm X Jazz Festival in Oakland. (Photograph by Kamau Amen-Ra.)

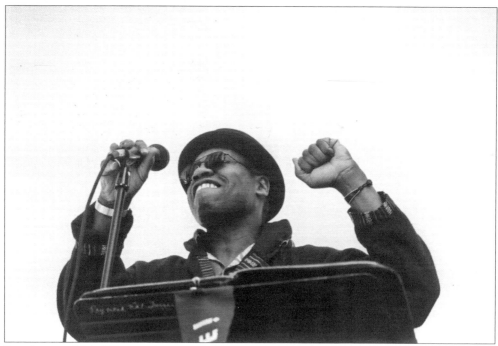

Poet Raymond "Nat" Turner oftentimes performs with the musical group Upsurge. This photograph was taken at a performance in Mosswood Park in Oakland. (Courtesy Kamau Amen-Ra.)

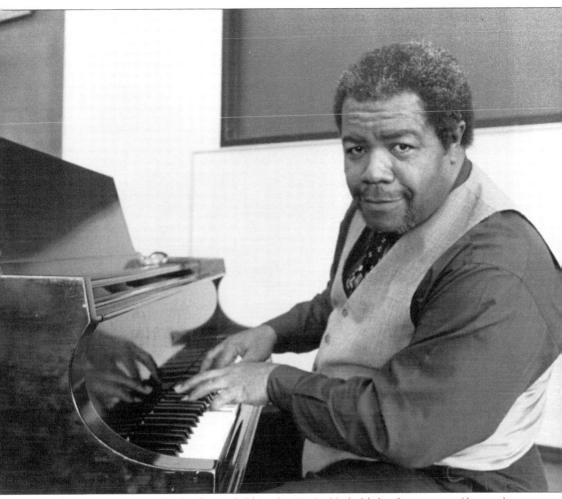

Pianist Ed Kelley came to Oakland as a child in the 1940s. He held the distinction of being the pianist for the house band at the legendary San Francisco jazz club the Keystone Korner. A highly respected music educator, Kelley taught jazz at Oakland's Laney College for many years and was a mentor to young tenor saxophonist Robert Stewart, among others. Kelley passed away in 2005. (Photograph by Kathy Sloane.)

Pictured here is storyteller and photographer Glodean Champion shot in her Oakland studio. Glodean's photography and prose work celebrate the link between Oakland history and myth, capturing images that open untold stories and using words that describe the place she also calls home. (Photographs by Glodean Champion.)

Three

THE MEETING OF GREAT WRITERS AT THE STATION

Pictured is one of the many amazing photographs by Oakland photographer Glodean Champion. Her signature style of elegant landscape portraits continues to inspire and connect residents of Oakland, especially in the Lake Merritt neighborhood, where this shot was captured. (Photograph by Glodean Champion.)

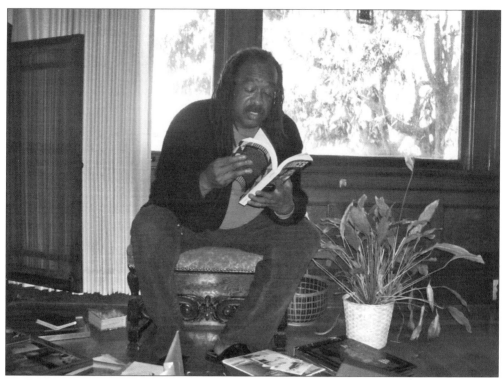

This photograph shows Reginald Lockett in his Oakland home reading poetry from his library. This photograph was taken in 2006. (Photograph by Duane Deterville.)

Pulitzer Prize–winning author Alice Walker was a resident of Oakland. She still oftentimes attends church and speaks at events in Oakland. (Photograph by Kamau Amen-Ra.)

The author of one of the most iconic plays in black theater, *for colored girls who have considered suicide / when the rainbow is enuf*, Ntozake Shange developed much of this self-described "choreopoem" around the Oakland area—in cafés and other performance spaces. A novelist, performance artist, playwright, and poet, Ntozake currently makes her home in Oakland. (Courtesy Jerry Thompson.)

Pictured here is best-selling author April Sinclair, whose trilogy of Oakland-based tales celebrated the voice of thousands of young black female teenagers coming of age in the 1970s, 1980s, and 1990s. Her most well-known book is *Coffee Will Make you Black*. (Courtesy Jerry Thompson.)

Hip-hop journalism legend Danyel Smith came of age in Oakland and wrote some of her earliest articles on hip-hop for the local newspapers. She's been the editor in chief for *Vibe* magazine twice and has also published two novels. Her first novel, *More Like Wrestling*, is about coming of age in Oakland.

Poet, journalist, essayist, and educator Kofi Natambu was editor of *Solid Ground: A New World Journal* in Detroit, Michigan, before coming to Oakland to make his home. He was one of the earliest critics writing about hip-hop and rap before they became a worldwide phenomenon. An extraordinarily insightful critic of black literature, art, and music, his published works include the book of poetry *The Melody Never Stops* and a biography on Malcolm X in the Critical Lives series titled *Malcolm X*. (Photograph by Chuleenan Natambu.)

MARLON RIGGS REMEMBERED

a free program recalling the man and his art

featuring his films
NO REGRET/
NON, JE NE REGRETTE RIEN
a new film on Black gay men confronting AIDS
and ANTHEM
a short that celebrates

live music and poetry by
BLACKBERRI
ALAN MILLER
MARVIN WHITE
commentary by
NICOLE ATKINSON
JACK VINCENT

photo: Ron Simmons

Doors open at 7:30
FRIDAY FEBRUARY 10 8:00 pm
BERKELEY PUBLIC LIBRARY
CENTRAL READING ROOM
2090 Kittredge at Shattuck Info: 510.644.6100

SPONSORED BY THE FRIENDS OF THE LIBRARY
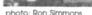
To request a sign language interpreter for this event,
call 510-644-6095 or 510-548-1240 (TDD) by February 1st.

EVERY MONTH IS AFRICAN AMERICAN HISTORY MONTH. -- Kerrigan Black

Filmmaker Marlon Riggs was also a resident of Oakland. This handbill is for an event at the Berkeley Public Library that commemorated his passing in 1994 from an AIDS-related illness. (Courtesy AAMLO.)

There may be no other poet that represents the working-class-blues spirit of Oakland better than Reginald Lockett (right). He was a key contributor to the black arts movement on the West Coast during the late 1960s and early 1970s. His work is represented in the influential 1968 anthology *Black Fire*. Born in Berkeley and raised in West Oakland, Lockett is known for performing poems that delineate the essence of Oakland's black folks from his long, firsthand experience. Poems like *Oaktown CA* and *Ghost Town* are unique illustrations of Oakland that he sometimes performs with a poetry ensemble called Wordwind Chorus. This 1995 photograph was taken at Marcus Bookstore in Oakland when Lockett was presenting his book of poetry *Where the Birds Sing Bass*. Poet Piri Thomas stands to his right. (Courtesy Duane Deterville.)

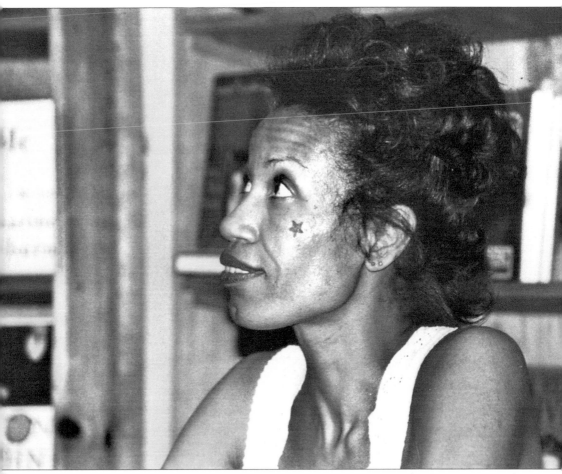

Oakland author Ishmael Reed said that Xam Wilson Cartier "is to writing what Betty Carter and Sarah Vaughn are to music." Xam (her name means "harmony") is author of the two novels *BeBop, Rebop* and *Muse Echo Blues*. She was a resident of Oakland in the 1990s, when her prose novels were critically acclaimed as the equivalent of jazz in literature. (Photograph by Horace Mansfield.)

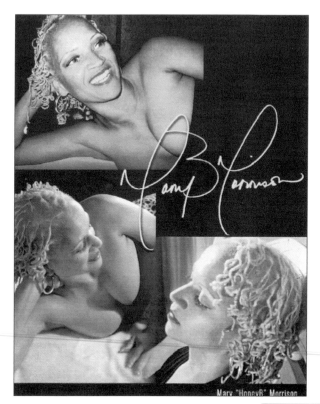

Mary "HoneyB" Morrison

Pictured here is Oakland's author Mary B. Morrison, whose rise to national popularity came from her legendary grassroots marketing of her first self-published novel, *Soul Mates Dissipate*, of which she sold millions of copies from the trunk of her car. She now celebrates her continuous string of bestselling novels, such as *Somebody's Got To Be on Top* and *He's Just A Friend*. (Courtesy Mary B. Morrison.)

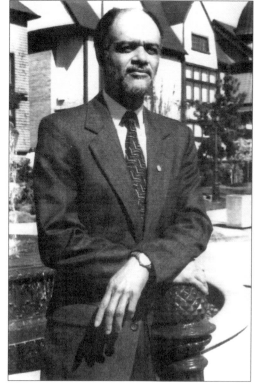

Actor, producer, and filmmaker Michael Lange is probably best known for his one-man performances portraying Malcolm X. His reenactments of Malcolm X's profound and legendary speeches "The Ballot or the Bullet" and "Message to the Grassroots" have been performed all across the country. This photograph was taken at Preservation Park near the location of the original Oakland Ensemble Theater. Lange served on the board of directors of the theater from 1982 to 1986. (Courtesy Michael Lange.)

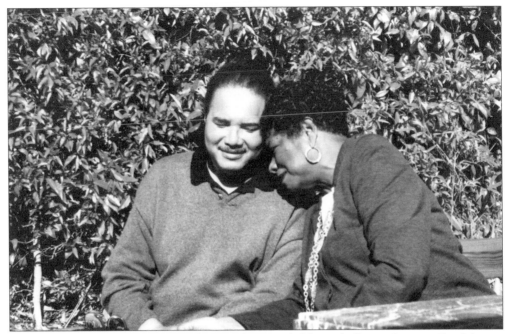

The acclaimed author of *Standing at the Scratch Line* and *Echoes of a Distant Summer*, Guy Johnson is seen in this photograph sharing an affectionate moment with his mother, Maya Angelou, in the backyard of his Oakland home. The legendary Maya Angelou was also once an Oakland resident who produced plays at the Alice Arts Theatre. (Courtesy Guy Johnson.)

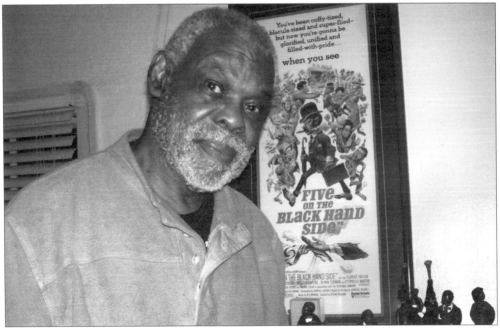

Writer Charlie Russell moved to Oakland as a child in 1942. He graduated from Oakland Technical High School. Russell received the NAACP award for writing the script to the film *Five on the Black Hand Side*. *Ebony* magazine recognized the film as one of the 10 best African American films of all time. (Photograph by Duane Deterville.)

Playwright, essayist, poet, and activist Marvin X (El Muhajir) is one of the essential architects of the black arts movement on the West Coast. He cofounded the Black House, which was a center for community theater performances in San Francisco, and the Black Arts West Theatre. He was born in Fowler, California, but spent a significant part of his childhood in Oakland. One of Marvin X's most poignant plays is the one he wrote about a meeting in an Oakland crack house with Black Panthers founder Huey Newton titled *A Day in the Life*. The play was performed by the Recovery Theatre. This photograph shows the cast for the play following a rehearsal in Oakland. From left to right are J. B. Sanders, Jeffrey Greer, Rudy ?, Marvin X, Tureeda Mikell, Roxanne Ware, Naru Kwina, and Toussaint Haki. ((Photograph by Kamau Amen-Ra.)

One of the most dynamic cultural events in Oakland is the Malcolm X Jazz Festival, which is hosted annually by the East Side Arts Alliance. Pictured from left to right, legendary poets Umar Bin Hassen of the Last Poets, Marvin X, and Amiri Baraka enjoy a moment together at the festival. (Photograph by Kamau Amen-Ra.)

Pictured is Oakland poet Gene Howell, writer and host of the popular poetry-reading series and open-mic event Fireback! Poetry on the Waterfront. This series featured a continuous flow of new young talent throughout the city, at times featuring many tribute evenings celebrating June Jordan and Opal Palmer Adisa. (Courtesy Halifu Osumare.)

Oakland poet, essayist, and professor Opal Palmer Adisa (left) has written several volumes of poetry, including the acclaimed *Eros Muse*. She sometimes performs in a duet setting with fellow poet and former poet laureate of San Francisco Devorah Major (right). The name of the group is Daughters of the Yam and it sometimes features the accompaniment of bassist Dewayne Oakley. This 1994 photograph was taken in West Oakland. (Photograph by Kathy Sloane.)

Born in 1956 in Goldsboro, North Carolina, poet Forrest Hamer has won critical acclaim for his masterful poetry. Amongst his volumes of poetry are *Call and Response* (1995) and *Middle Ear* (2000). Hamer is also a practicing psychologist and has a psychotherapy business in Oakland. (Courtesy Forrest Hamer.)

Edsel Matthews and Kimathi Asante founded Koncepts Cultural Gallery in 1984. Matthews (right) is shown in this photograph with jazz clarinet legend John Carter (left) at Koncepts original location on Telegraph Avenue. (Photograph by Horace Mansfield.)

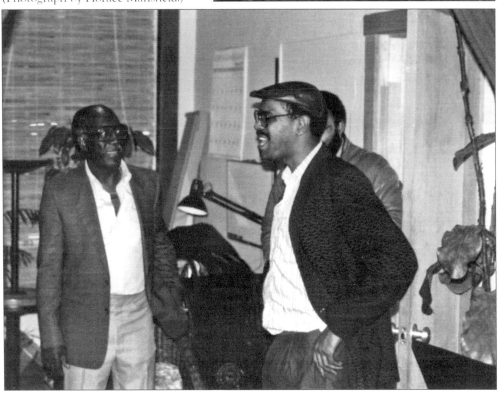

DEWAYNE OAKLEY

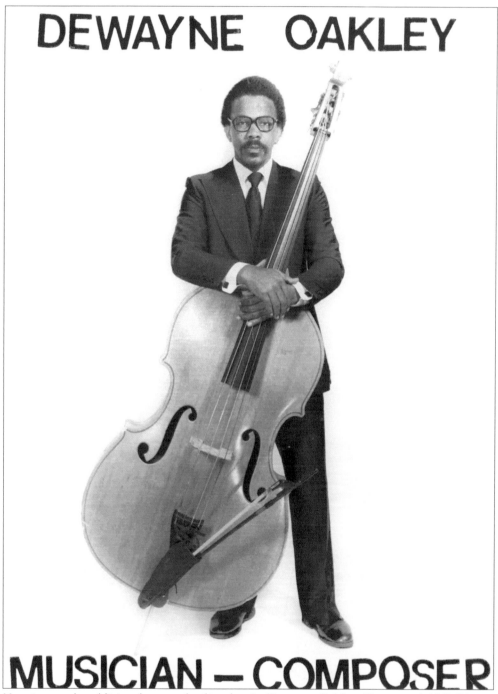

MUSICIAN — COMPOSER

Here is an early publicity photograph of jazz bassist Dewayne Oakley. (Courtesy AAMLO.)

This handbill was the first flyer for Koncepts Cultural Gallery's original location in Jenny Lind Hall at 2267 Telegraph Avenue. The artwork is by Oakland artist Jimi Evans. (Courtesy Art Sato Collection.)

Koncepts Cultural Gallery moved to 480 Third Street in Jack London Square in 1987. This handbill showcases the type of world-class jazz musicians the club had performing there years before Yoshi's Night Spot moved to Jack London Square. (Courtesy Art Sato Collection.)

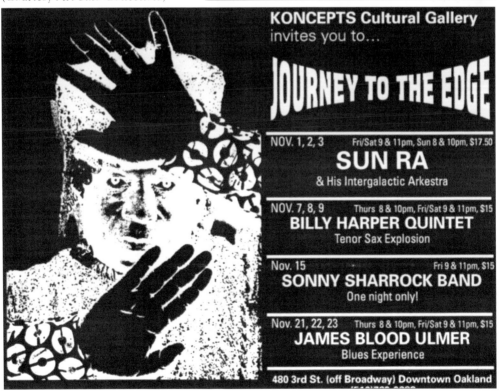

KONCEPTS Cultural Gallery invites you to...

JOURNEY TO THE EDGE

NOV. 1, 2, 3 Fri/Sat 9 & 11pm, Sun 8 & 10pm, $17.50
SUN RA
& His Intergalactic Arkestra

NOV. 7, 8, 9 Thurs 8 & 10pm, Fri/Sat 9 & 11pm, $15
BILLY HARPER QUINTET
Tenor Sax Explosion

Nov. 15 Fri 9 & 11pm, $15
SONNY SHARROCK BAND
One night only!

Nov. 21, 22, 23 Thurs 8 & 10pm, Fri/Sat 9 & 11pm, $15
JAMES BLOOD ULMER
Blues Experience

480 3rd St. (off Broadway) Downtown Oakland

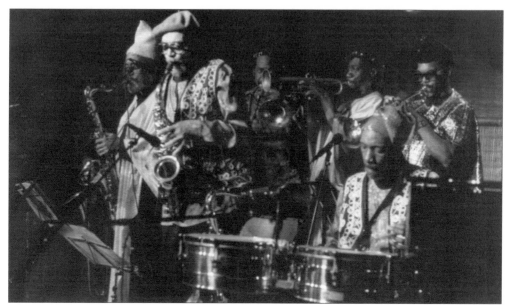

This photograph is from a benefit concert for music legend Sun Ra in 1992, when he had fallen ill. The tribute was at the Third and Washington Street location. Sun Ra's band played with some local musicians in addition to the regular working band. Pictured from left to right are Pat Patrick (saxophone), Marshall Allen (saxophone), Michael Ray (trumpet), John Gilmore (percussion), and unidentified (trumpet). Sun Ra has an artistic link to Oakland as well. In 1974, he filmed the cult classic *Space is the Place* near Oakland's Old Merritt College campus. (Photograph by Kamau Amen-Ra.)

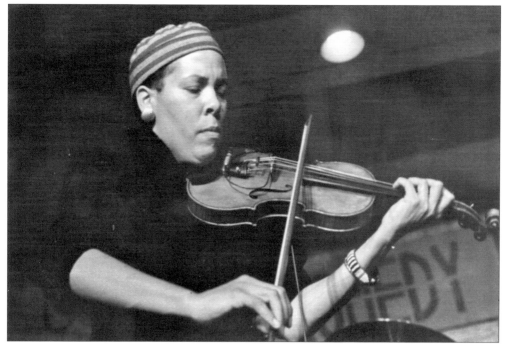

Violinist India Cooke is shown here performing at the Sun Ra benefit concert at Koncepts Cultural Gallery in 1992. (Photograph by Kamau Amen-Ra.)

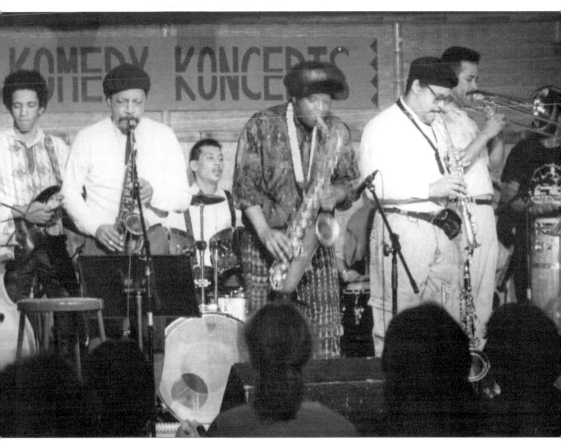

Performing at Koncepts Cultural Gallery are, from left to right, J. B. (soprano saxophone), Ghasem Batamuntu (tenor saxophone), Mack Oakley (alto saxophone), and an unidentified guitarist and drummer. (Photograph by Kamau Amen-Ra.)

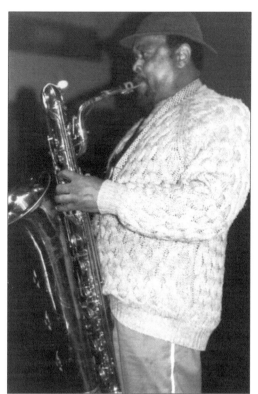

Oakland resident Prince Lasha is known for the 1960s free jazz album that he recorded with Sonny Simmons titled *Firebirds*. He comes from the same community and generation of Texas musicians that produced Ornette Coleman, John Carter, and Charles Moffett. This photograph was taken at a 1988 performance by Odean Pope at Koncepts Cultural Gallery. Prince Lasha accompanied Pope in the performance. (Photograph by Horace Mansfield.)

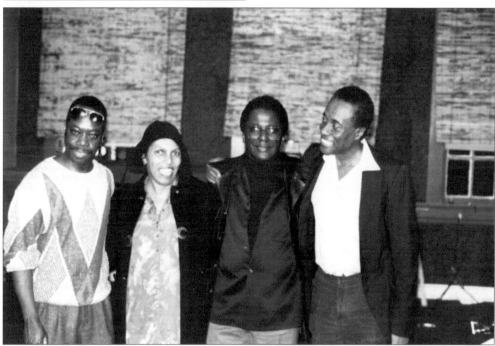

Koncepts Cultural Gallery oftentimes hosted great musicians. From left to right are drummer Andrew Cyrille, Laverne Hill, pianist Andrew Hill and bassist Richard Davis. This photograph was taken in 1987. (Photograph by Horace Mansfield.)

Four

LIFT YOUR HEART, KICK UP YOUR FEET, CREATE ART, AND LIVE FOREVER!

This 1999 photograph shows the musical group Umoja in front of the Expressions Gallery in Old Oakland. Pictured from left to right are Damu Sudi Ali, Algie Glasco, M. B. Hanif, Kamau Seitu, Kenneth Byrd, and Mark Wright. Oakland's black-owned gallery spaces have been an endless source of support for local artists and oftentimes show internationally recognized artists from outside the community. One of the most prominent venues was the Grande Oak Gallery, which was founded by Roy Sanders. The Grande Oak Gallery was located at 544 Grande Avenue. Other galleries include Thelma Harris Gallery on College Avenue, Samuel's Gallery in Jack London Village, Expressions Gallery in Old Oakland, Shamwari Gallery on Piedmont Avenue, Joyce Gordon Gallery on Fourteenth Street, and the Stoneridge Gallery in Jack London Square. (Photograph by Kamau Amen-Ra.)

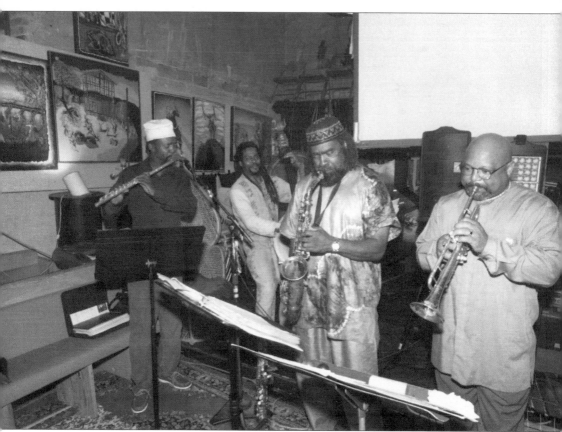

This live performance by the group Umoja was at the Expressions Gallery, formerly located at 815 Washington Street in the Old Oakland district. The gallery owner was artist Alan Laird, who oftentimes showed the work of incarcerated artists as well as his own work. From left to right, the performers are Kenneth Byrd (flute), Algie Glasco (bass), M. B. Hanif (saxophone), Kamau Seitu (not seen on drums), and Mark Wright (trumpet). (Photograph by Kamau Amen-Ra.)

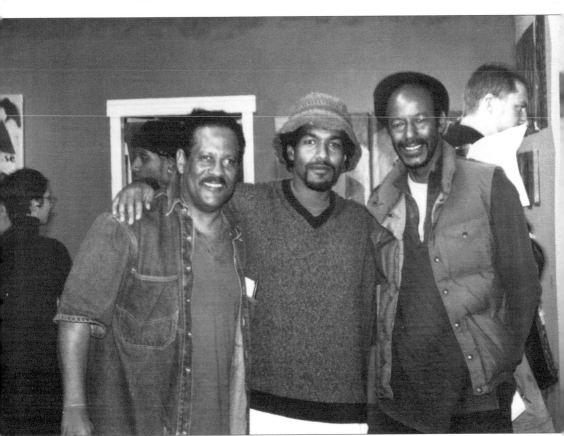

Expression Gallery owner Alain Laird (left) poses with artists Eesuu (center) and Woody Johnson (right). This photograph was taken at an exhibit of paintings by Gathinji WaMbire at the gallery Oakland Art dot Com. (Courtesy Randolph Belle.)

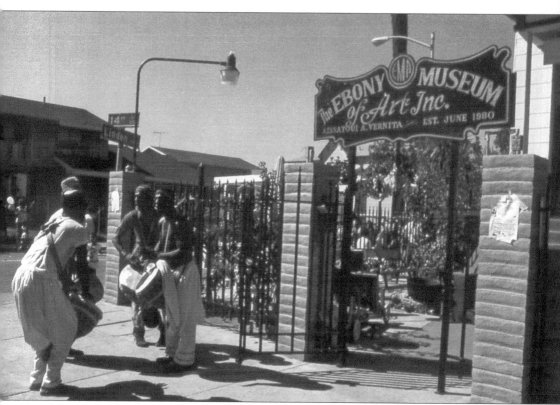

African djembe drummers perform in front of the Ebony Museum, founded by artist Aissatoui A. Vernita. This photograph was taken in 1987 at the Fourteenth and Linden Streets location. (Photograph Kamau Amen-Ra.)

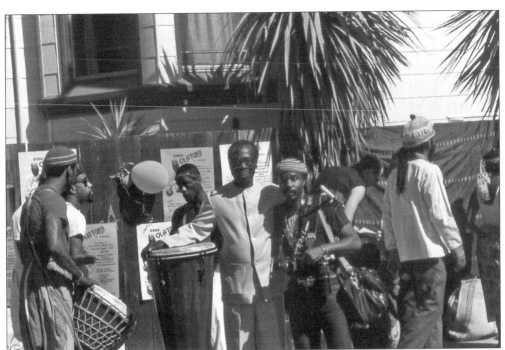

Master drummer Babatunde Olatunji paid a visit to the Ebony Museum in 1987. This photograph shows him with photographer Kamau Amen-Ra. (Photograph by Kamau Amen-Ra.)

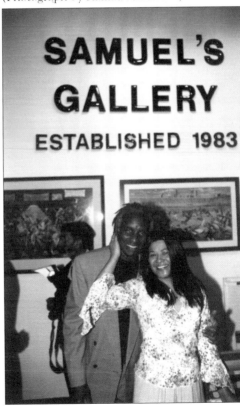

Seen here is Samuel's Gallery at the opening of the Ernie Barnes Exhibit in Jack London Square. The gallery was established in 1983 and occupied the Jack London Village location in 1985. Gallery owner Samuel Fredericks is seen here with artist Ernie Barnes's business assistant Luz Rodriguez. (Photograph by Jim Tyler; courtesy Samuel Fredericks.)

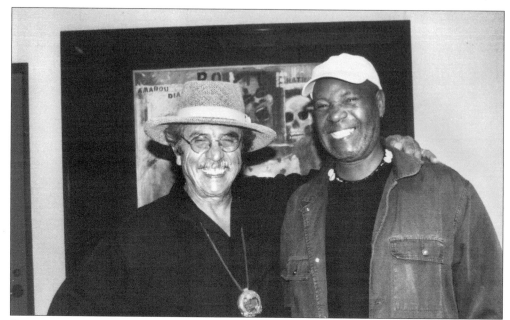

Emory Douglass was the minister of culture for the Black Panther Party. He was the primary illustrator for the *Black Panther* paper throughout its publication. Emory is shown here with Chicano artist Malaquias Montoya during a reception for Malaquias's exhibit at the Asian Resource Gallery in Oakland's Chinatown. This 2003 photograph documents the cross-cultural solidarity found amongst political artists in Oakland. (Courtesy of Greg Morizumi.)

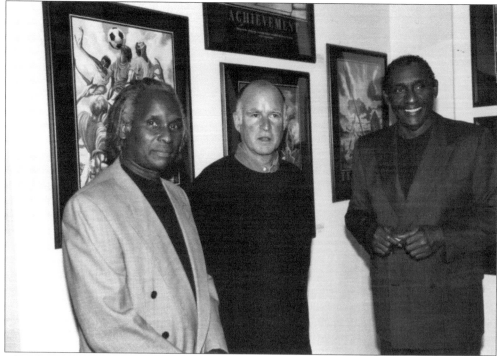

This photograph shows, from left to right, artist Ernie Barnes, former Oakland mayor Jerry Brown, and gallery owner Samuel Fredericks. (Photograph by Jim Tyler; courtesy Samuel Fredericks.)

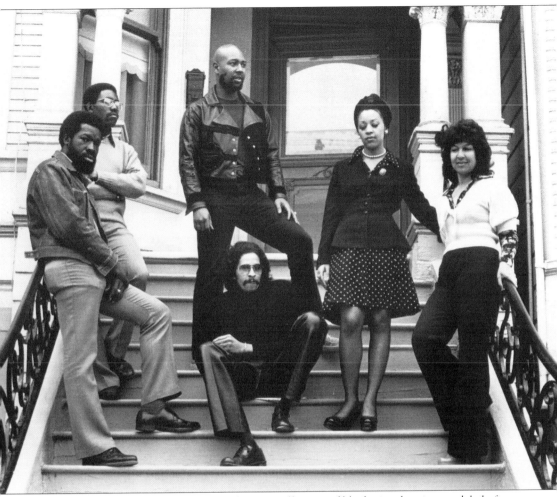

The Bay Area Black Artists group (BABA) was a collective of black visual artists modeled after the Africobra artists collective in Chicago. BABA included, from right to left, Casper Banjo, James Lawrence, Joe Geran, Cleveland Bellows (seated), Carol Ward Allen, and Marie Johnson-Calloway. These Oakland artists were featured in the influential two-volume book titled *Black Artists on Art*, which was published in 1971. In the early 1970s, they helped to define the black aesthetic in visual arts. Significantly, Carol Ward Allen went on to become the president of the BART (Bay Area Rapid Transit) Board of Directors. (Courtesy Casper Banjo.)

Pictured on the left is Marvin K. White, performer and Lambda Literary Award–nominated poet for his collections *Last Rights* (Redbone Press) and *Nothin'Ugly Fly* (Redbone Press). He is also a playwright, visual artist, and a community arts organizer. On the right of him is Michael Ross, who has become well-known in the past two decades for his collaborative arts shows and performances pieces with authors and poets, many of which featured Marvin K. White, Wayne Corbett, Jerry Thompson, and Alan Miller. (Courtesy Jerry Thompson.)

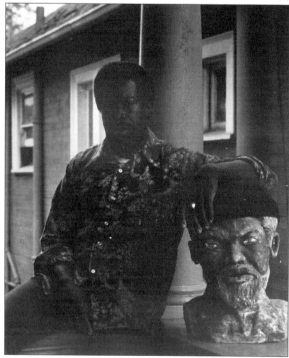

Visual artist Casper Banjo was born in 1937 in Memphis, Tennessee, and arrived in Oakland in the 1950s. His first studio was a 13-room Victorian house formerly located at 831 Linden Street in West Oakland. He is known for his prints of surreal anamorphic forms, oftentimes with a background of his trademark brick pattern. The brick pattern shows prominently in his work and is a representation of the urban environment in which he creates his art. Banjo is shown here with his portrait bust, which was created by sculptor Ben James. This photograph was taken by renowned art historian Richard Powell in the mid-1980s at Banjo's 815 Apgar Street studio. Casper Banjo currently resides in East Oakland. (Courtesy Casper Banjo.)

Casper Banjo often expanded the theme of the brick pattern to clothing. He models one of his hand-painted creations in this photograph.

Donald Greene, pictured here in his home studio, is probably one of the greatest self-promoters and educators in Oakland and the Bay Area. He was born and raised in the Bay Area and now lives in Oakland. (Courtesy Donald Greene.)

Oakland painter and educator Jimi Evans is shown in his studio with his latest body of work. (Courtesy Jimi Evans.)

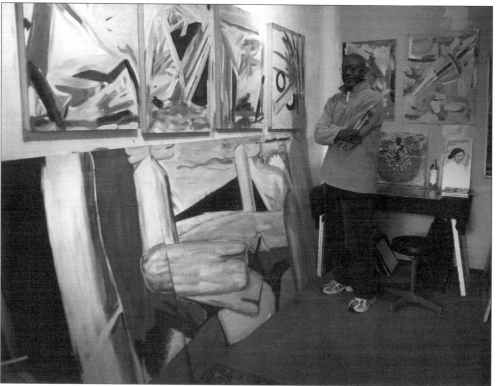

Artist, photographer, and educator Nashormeh Lindo has lectured at the San Francisco Museum of Modern Art and the California College of the Arts, among other arts institutions. (Courtesy Nashormeh Lindo.)

Painter Marvin H. McMillan is the product of the East Oakland community. Marvin has exhibited his work in many local venues. (Courtesy B. Malick.)

Artist Ben Hazzard has been a professor of art and the director of the Crafts and Cultural Arts Department for the City of Oakland. Hazzard designed the flag for the county of Alameda. (Courtesy Ben Hazzard.)

This photograph of Oakland artist Anne Marie Hardeman with Joe Sam was taken at the Shamwari Gallery, which was located at 4176 Piedmont Avenue. The gallery specialized in the Shona stone carvings of Zimbabwe but occasionally showed the work of artists, such as Joe Sam. (Photograph by Kathy Sloane.)

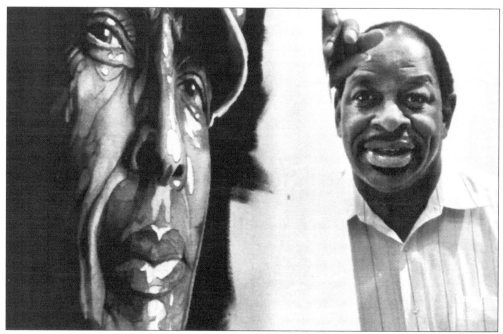

Painter James Gayles worked as an Emmy award–winning illustrator and graphic designer for a New York television station before moving to Oakland. In Oakland, he has distinguished himself with several art exhibits that focus on music. This photograph shows him with a portrait of musician and singer Charles Brown that was done for an exhibit focusing on blues legends. (Courtesy James Gayles.)

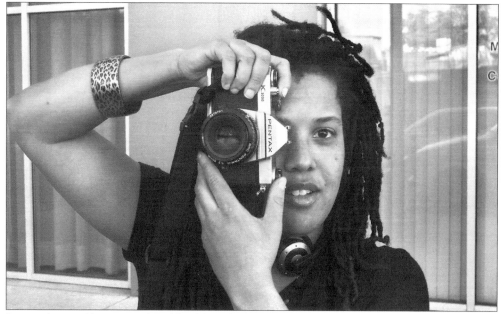

Pictured is a self-portrait of Oakland-based photographer and writer Jennifer Inez Ward. Her work has been showcased around the Oakland cafes and bookstores. A self-proclaimed "original soul sistah," her mission has been to continually renew our connection with Oakland's past and future. (Courtesy Jennifer Inez Ward.)

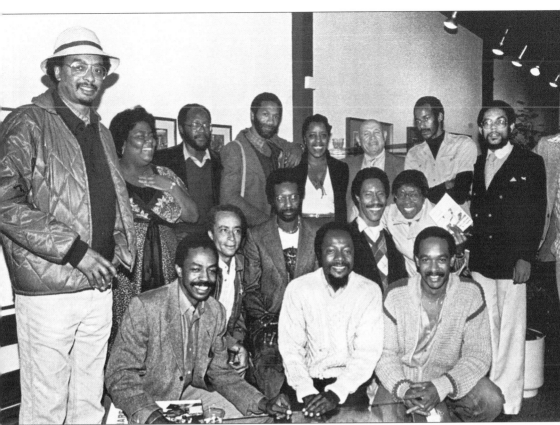

In 1981, the late African American master collage artist Romare Bearden's work was shown at the now-defunct Parsons Barnett Gallery on Piedmont Avenue in Oakland. This group photograph was taken for the opening reception, where he was greeted by many local literary and artistic luminaries. Pictured from left to right are the following: (first row) Deleon Harrison, Melvin Etterick (painter), David Bradford (painter/printmaker), David Henderson (writer), Jaffers Tremell, Gail Berkeley, and Reginald Lockett (writer); (second row) Arthur Monroe (painter, curator, and scholar), Violet Fields (painter) Jimi Evans (painter), Ray Holbert (painter), Mildred Howard (multimedia artist), Romare Bearden, Woody Johnson (sculptor/printmaker), and two unidentified. (Photograph by Kathy Sloane.)

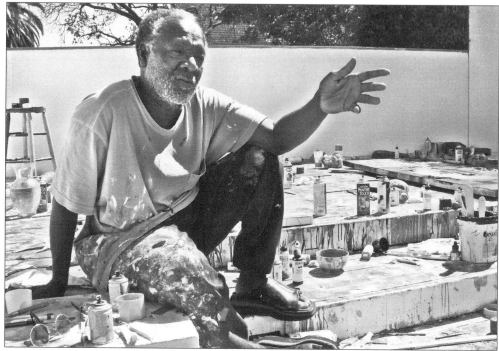

Currently an art professor at Oakland's California College of the Arts, world-renowned painter Raymond Saunders has exhibited his work in Europe, Africa, and Japan. He maintains studios in America and France. His work is held in the permanent collections of the Oakland Museum, the San Francisco Museum of Modern Art, and the DeYoung Museum, among others. These photographs were taken in his outdoor painting studio in Oakland. (Photograph by Duane Deterville.)

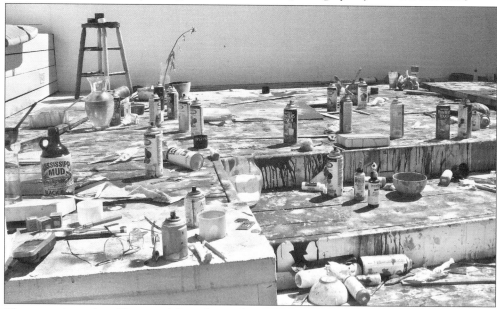

The open-air studio of Raymond Saunders is shown here. Saunders is known for paintings that use his mastery of drawing and his jazz-like sense of improvisation to absorb and redefine common objects as art. (Photograph by Duane Deterville.)

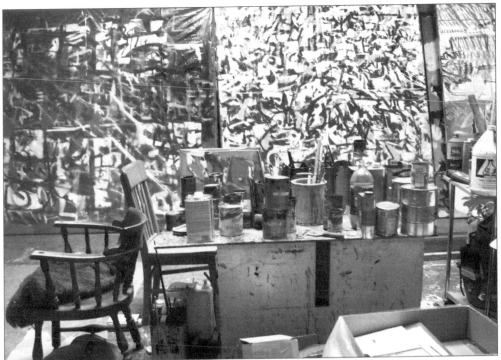

Paintings from a recent retrospective of the work of Arthur Monroe can be seen in this photograph of his East Oakland painting studio. (Photograph by Duane Deterville.)

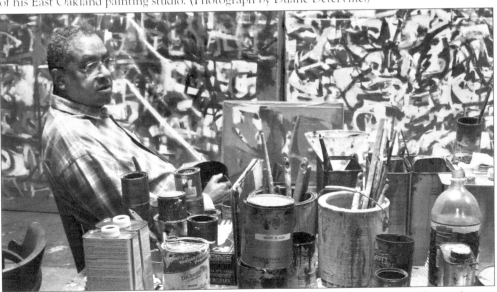

Arthur Monroe is a painter, curator, writer, and scholar who was born in Brooklyn and was a visual artist in New York during the era of abstract expressionism. As the western region director of the International Festival of African Arts and Culture (FESTAC) that took place in 1977 in Lagos, Nigeria, Monroe was responsible for organizing a delegation of 300 artists from 10 states in the western region of the United States. Monroe is currently the head registrar at the Oakland Museum. This photograph was taken in 2006 in his East Oakland painting studio. (Photograph by Duane Deterville.)

Painter Robert Colescott maintained a studio in Oakland for many years. His paintings are highly charged allegories about religion, sex, and race that have been exhibited internationally to critical acclaim. He was the first black artist to have his work shown in the Venice Biennale. This photograph was taken by artist, professor, and curator Leslie Stradford during Colescott's exhibit at the June Steingart Gallery in 2006.

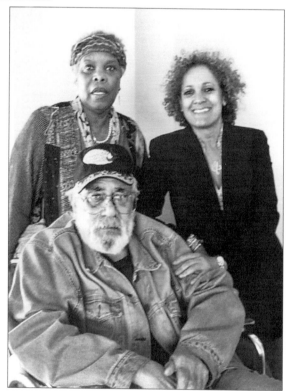

Shown standing from left to right are painter/curator Leslie Stradford, painter/art professor Mary Lovelace O'Neal, and Robert Colescott (seated). (Courtesy Jandava Cattron.)

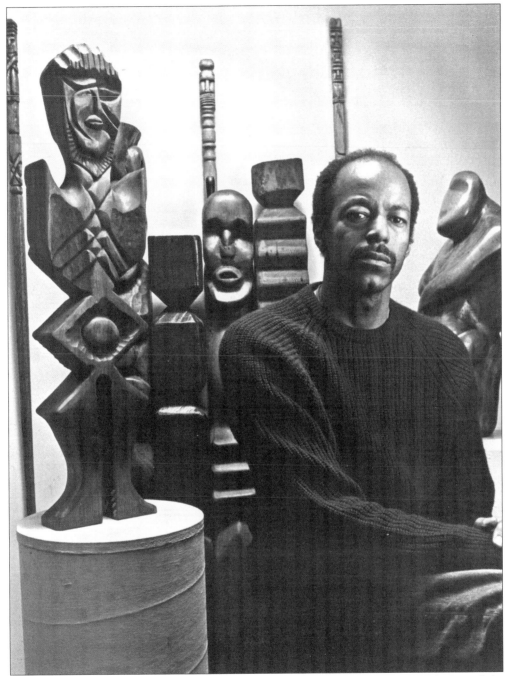

Pictured is beloved educator, artist, sculptor, and printmaker Woody Johnson. (Photograph by Larry Booth; Collection of Woody Johnson.)

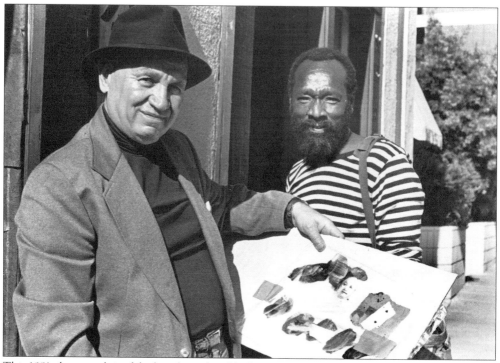

This 1981 photograph is of the late, legendary black artist Romare Bearden (left) with Oakland artist Raymond Saunders presenting some of his artwork to him. (Photograph by Kathy Sloane.)

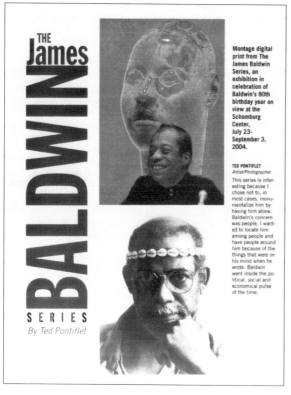

THE James BALDWIN SERIES By Ted Pontiflet

Montage digital print from The James Baldwin Series, an exhibition in celebration of Baldwin's 80th birthday year on view at the Schomburg Center, July 23-September 3, 2004.

TED PONTIFLET
Artist/Photographer

This series is interesting because I chose not to, in most cases, monumentalize him by having him alone. Baldwin's concern was people. I wanted to locate him among people and have people around him because of the things that were on his mind when he wrote. Baldwin went inside the political, social and economical pulse of the time.

This poster was created for Ted Pontiflet's exhibit of James Baldwin photographs at the Schomburg Center in New York City. (Courtesy Ted Pontiflet.)

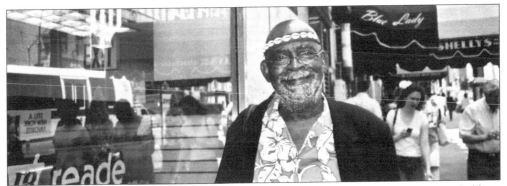

Photographer, painter, and printmaker Ted Pontiflet is probably best known for his James Baldwin series. The series was exhibited to critical acclaim in 2004 at the Schomburg Center for Research in Black Culture in New York City. Pontiflet graduated from Oakland's California College of Arts and Crafts and was its class president in 1961 and 1962.

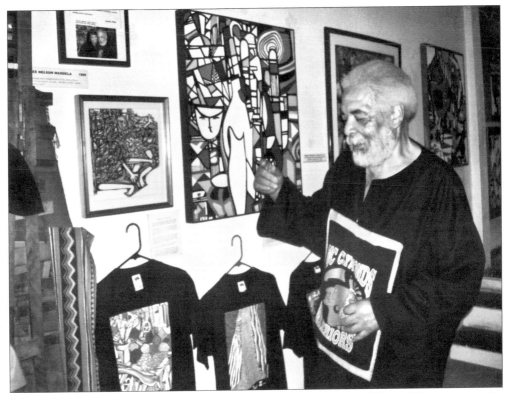

This 2006 photograph is of Oakland multimedia artist Arnold K. White. White grew up in West Oakland and attended McClymonds High School in the 1950s. His artwork has been used in Spike Lee's movies and can be found in the collections of the African American Museum Library and the African National Congress (ANC) headquarters in South Africa. (Photograph by Duane Deterville.)

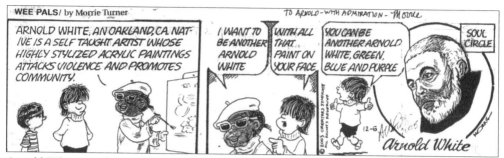

Arnold White was honored by Morrie Turner in his *Wee Pals* comic strip.

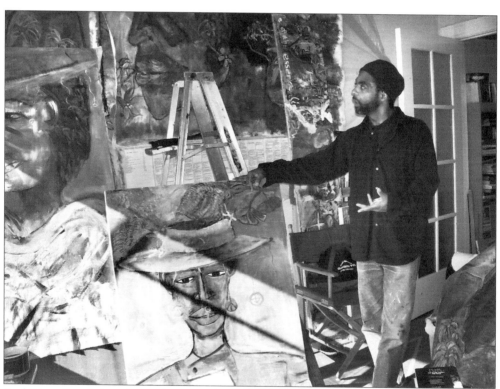

Paul Rigne Roach is a playwright, stage director, actor, filmmaker, and painter. He has used his paintings in stage productions as a way of carrying narrative. Most recently he's directed many of the traveling shows written by Tyler Perry and has worked on film with Mario Van Peebles. (Photograph by Duane Deterville.)

This poster, created by Oakland comic-strip artist Morrie Turner, celebrated the Annual Black Filmmakers Hall of Fame awards ceremony held at the Paramount Theatre on Broadway. (Courtesy AAMLO.)

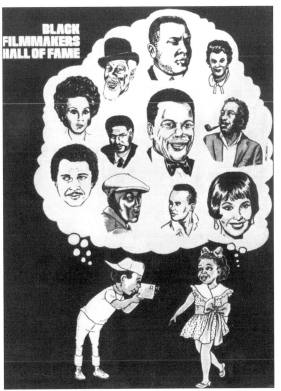

Pictured here is writer, educator, civil rights activist, and storyteller Daphne Muse. She has been an East Bay resident for 35 years, and her home in Oakland served at times as a salon and artist retreat. Her connections to Alice Walker and Rosa Parks are legendary anecdotes in the memoir of African American artists in Oakland. Her first children's book, *Children of Africa*, was published in 1970. (Courtesy Glodean Champion.)

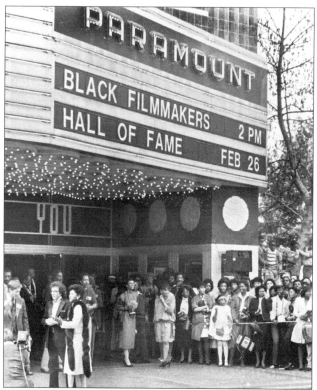

The Black Filmmakers Hall of Fame was founded in 1973. They held elegant events that honored such screen legends as Cicely Tyson, Clarence Muse, and the Nicolas brothers with the Oscar Micheaux Awards. Throughout the 1970s and 1980s, they hosted this formal event at Oakland's Paramount Theatre, ensuring that once a year Oakland would see legendary screen stars arrive in limousines. (Courtesy AAMLO.)

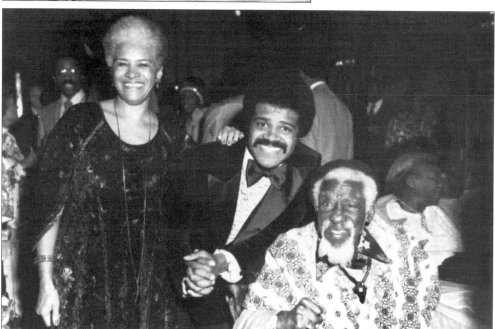

Actor Clarence Muse (seated right) received the Black Filmmakers Hall of Fame Award in 1973. He is known for being one of the earliest advocates of dignified roles for black actors. He is shown here at the 1978 gala with television journalist and author Jerri Lange and her son, actor Ted Lange. (Courtesy AAMLO.)

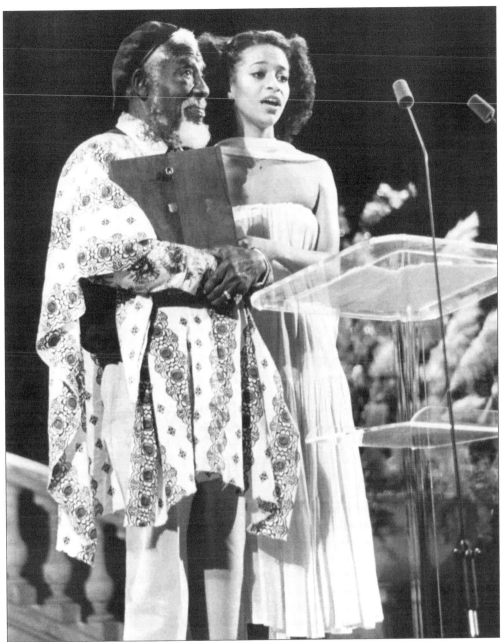

Debbie Allen (right) receives the Clarence Muse Youth Award from Clarence Muse at the Black Filmmakers Hall of Fame awards ceremony at the Paramount Theatre in 1978. (Courtesy AAMLO.)

When he took over the conductor's role as head of the Oakland Symphony in 1979 at age 32, Calvin Simmons became the first black conductor of a major metropolitan symphony orchestra west of the Mississippi. His impact on the community was remarkable. In 1982, he died tragically in a boating accident in New York. (Photograph by Mary Lawrence; Courtesy AAMLO.)

Oakland East Bay Symphony conductor Michael Morgan is known as "the people's maestro." He took over the leadership role of the symphony in 1990 and has brought more original premiere compositions to the Oakland Symphony than any other in the United States. An example of his work is the first performance of a composition written for full orchestra and a DJ as a soloist on turntables called Devolution. Devolution premiered in 2004. Known for his community involvement, Morgan has been a profound influence on Oakland's young musicians with the Music for Excellence organization that he helped to found. He visits 50 schools a year. (Courtesy Oakland East Bay Symphony.)

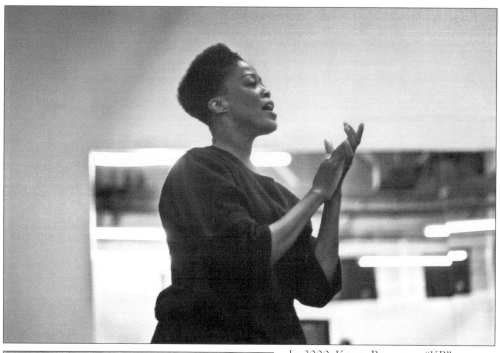

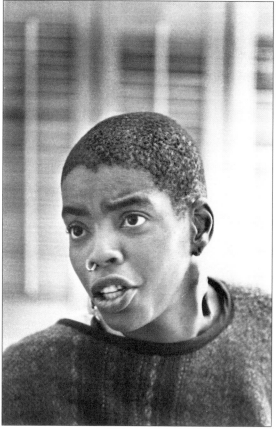

In 2000, Karen Brown, or "KB" as she is affectionately called, became the artistic director of the Oakland Ballet and as such the first black woman to head a major metropolitan ballet company. She had already made her mark in the world of dance as a principle dancer for the Dance Theater of Harlem from 1973 to 1995. In 2005, she premiered Donald McKayle's ballet *Ella*, which paid homage to Ella Fitzgerald with music by Marcus Shelby and vocals by Ledisi. (Photograph by Alan Kimara Dixon.)

This is an early photograph of the one and only Luisah Teish, dancer, educator, writer, yoruba priestess, and poet. She is one of the first teachers at Everybody's Creative Art Center, the collective that later became Criticaster Dance Theater and the Alice Arts Center. (Courtesy Luisah Teish.)

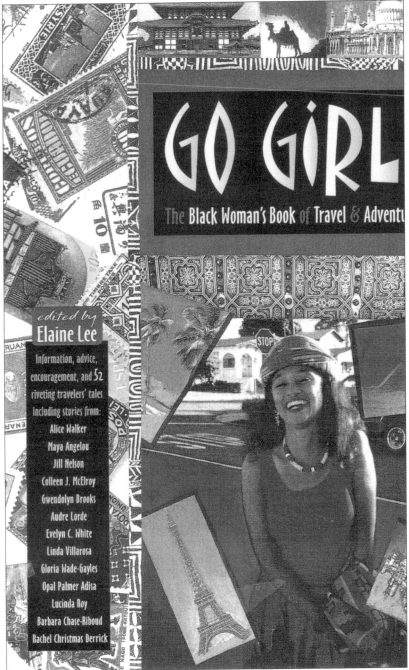

Pictured here is Oakland travel writer and community events organizer Elaine Lee, well-known throughout the Bay Area for her critically acclaimed anthology *Go Girl Travel! The Black Woman's Book of Travel and Adventure*. This first-of-a-kind collection featured many Oakland authors, such as Alice Walker, Evelyn C. White, and Maya Angelou. She continues to inspire many up-and-coming writers to take adventurous leaps into other landscapes while honoring the ancestors by keeping their hearts in Oakland. (Courtesy Elaine Lee.)

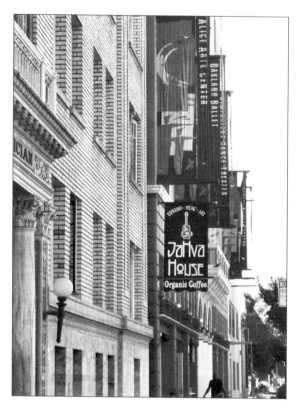

The Jahva House café is located adjacent to the Malonga Casquelourd Center for the Arts on Alice Street. The Alice Street location was originally called Victor's Café and was well-known for its poetry readings. The Jahva House's original location was on Lakeshore Avenue, where it made its mark as a prime location for artists, writers, and musicians to gather. It is one of the premiere locations for Oakland's burgeoning spoken-word scene. The Jahva House is owned by musician Dwayne Wiggins and his wife Michelle. (Photograph by Duane Deterville.)

Singer, songwriter, and producer Dwayne Wiggins is shown in this photograph taken in 1995 at a video shoot for the singing group Emage. (Photograph by Traci Bartalow.)

Five

THE HOME
OF AFRICAN
DIASPORIC ARTISTS

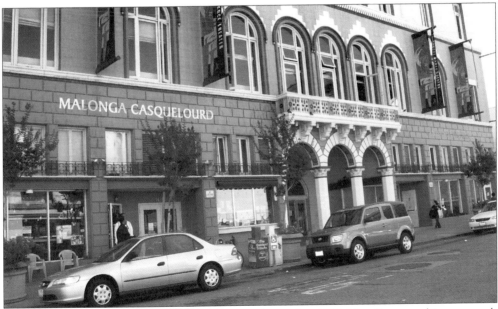

The Malonga Casquelourd Center for the Arts is located at 1428 Alice Street and is very much at the center of Oakland's African diasporic cultural arts scene. It has a 400-seat theater and five dance and rehearsal studios. In addition, it has three floors of residential apartments rented to performing artists. Oakland has been the home of many black artists from around the world, and many of them either held residency or taught at the Malonga Center. The Malonga Center is the culmination of many artists who have contributed their talents to the dance studios that have evolved into this dynamic institution. Everybody's Creative Art Center, Citicenter Dance Theater, and the Alice Arts Center eventually evolved into the Malonga Center. It has housed the Dimensions Dance Theater, the Oakland Ballet, and the Oakland Ensemble Theater, among other performing companies. (Photograph by Duane Deterville.)

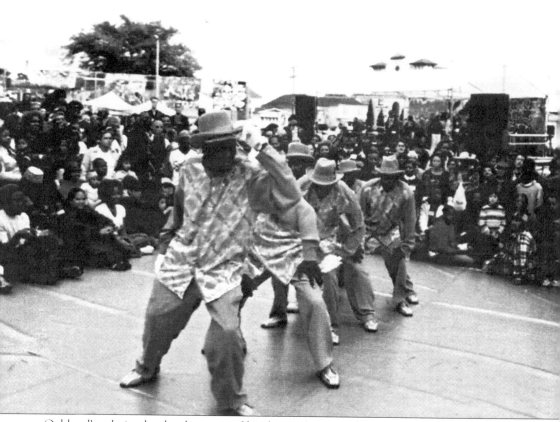

Oakland's role in the development of hip-hop culture is oftentimes under-documented. The dance group in this photograph is the Black Resurgents. They were pioneers of the dance styles known as "boogaloo," "steppin'," and "poppin'," all of which are part of the foundation of hip-hop dance. The members of the group, not in order of appearance, are Gregory "Debonaire" Lasiter, Victor "Instant Hear" White, Larry "Rubberband Man" Robertson, William "Mr. Penguine" Randolph, E. Vic "Crowd Pleaser" Randolph, and Ricky G. "The Robot" Gantt. (Photograph by Traci Bartalow.)

Oakland choreographer and dancer Corey Action has contributed his talent to many videos and stage performances. (Photograph by Traci Bartalow.)

Cameroonian master drummer Malonga Casquelourd was one of the pioneers of African dance in the Bay Area. He was the lead dancer for the Congolese National Dance Company and cofounded the Congolese Workshop, which was the first African dance and drumming workshop in the United States. His dance and performance ensemble Fua Dia Congo was based in Oakland for many years and was one of the most dynamic performance ensembles in the Bay Area. (Photograph by Alan Kimara Dixon.)

Pianist and composer Rudy Mwongozi has for a long time been a force on the local progressive black music and jazz scene. An eloquent spokesman for the music, he is shown at a symposium on the life and music of Charlie Parker that was presented in 2006 by Sankofa Cultural Institute at the House of Unity, located in East Oakland. (Photograph by Kathy Sloane.)

Saturday, March 13

7:30 p.m.

SONWA & UNIVERSAL ROOTS MUSIC

Presents

word Wind chorus

lewis jordan brian auerbach reginald lockett qr hand jr

with WONGOZI The Sounds of New World Afrikah & host/poet/MC NUBIA

@ the Alice Arts Center, Studio D

$10

The Wordwind Chorus, featuring from left to right the writers Q. R. Hand Jr., Reginald Lockett, Brian Auerbach, and musician Lewis Jordan, is a good example of the high standard of performance the Alice Arts Theater is known for. (Courtesy Reginald Lockett.)

The Alice Arts Center often hosts world-class master musicians from the continent of Africa and the African diaspora. Yoruba master drummer Babatunde Olatunji is shown here during a workshop with local dance treasure Rehema Namsa. Born and raised in West Oakland, Namsa's dance skills take her on regular trips to Africa. (Photograph by Kamau Amen-Ra.)

Master drummer C. K. Ladzekpo is part of a family of master drummers and dancers from the Anlo-Ewe peoples of Ghana, West Africa. He has taught classes and led rehearsals and performances for many years at the Alice Arts/Malonga Casquelourd Center for the Arts. Ladzekpo was one of the first African musician/scholars to bring the study and practice of African music to American universities. He heads the African Music Program at U.C. Berkeley and is the artistic director of the Mandeleo Institute in Oakland. (Courtesy C. K. Ladzekpo.)

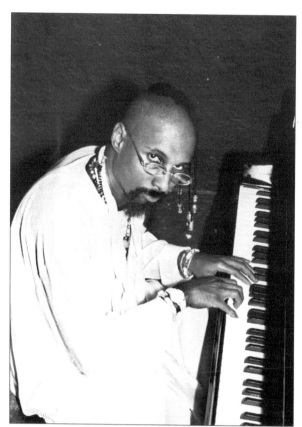

Afro-Cuban pianist and recording artist Omar Sosa was a resident of Oakland for several years. He has collaborated with the Dimensions Dance Theatre and the Oakland Symphony. This photograph was taken after a performance at the Alice Arts Center. (Photograph by Kamau Amen-Ra.)

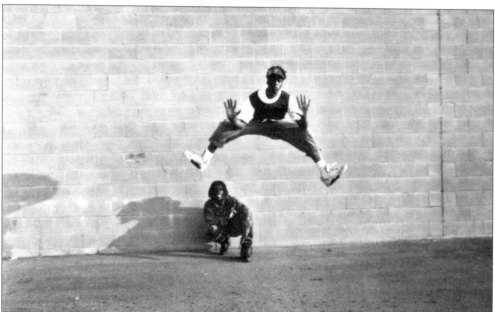

Choreographer and music artist Flii Styles, along with Maddakks (kneeling), was a founding member of the highly influential dance troupe the Housing Authority. Styles can be heard on the sound track to the highly acclaimed 2005 dance documentary *Rize*. (Photograph by Traci Bartalow.)

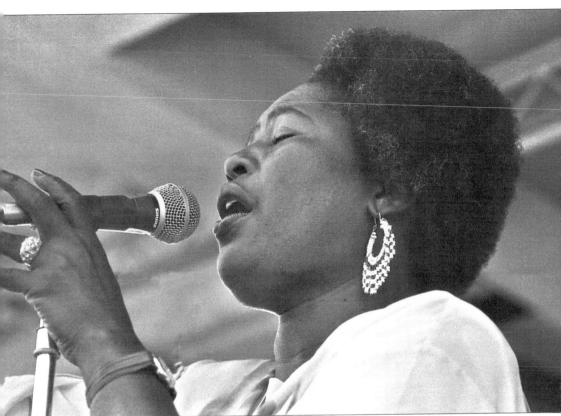

Pictured here is Afro-Cuban singer, performer, recording artist, and Yoruba priest Gladys Bobi Cespedes. She cofounded the Afro-Cuban music group Conjunto Cespedes. This photograph was taken at the Malcolm X Jazz Festival. (Photograph by Kamau Amen-Ra.)

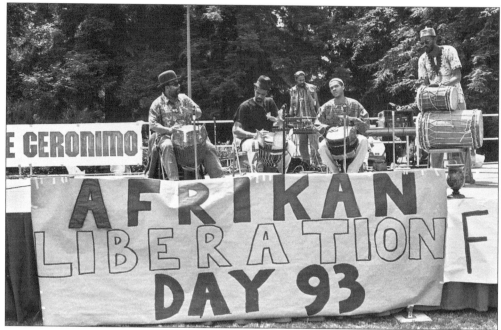

Seen is Afrikan Liberation Day in 1993 at Mosswood Park in Oakland. Featured here, from left to right, are well-known community drummers Mosheh Milone, Harun Black, Achebe Hoskins, John Provost, and Greg Hodge. These community drummers both individually and as a group open many events with an African spirit. Hodge is known for opening events with a call to the ancestors with the African tradition of pouring libations. (Photograph by Kamau Amen-Ra.)

Pictured from left to right at the Malcolm X Jazz Festival are poet Julian Carroll, jazz musician Kahlil El Zabar, and drummer Tacuma King. (Photograph by Kamau Amen-Ra.)

Poet and rapper Marcel Diallo has for a long time been a fixture on the spoken-word scene. He initially made his mark on the spoken-word scene with dynamic performances in such cafés as Victor's and the Jahva House before opening his own spot in the Fruitvale district called the Black Dot Café. In his role as the catalyst for a black arts district in West Oakland, he founded the Black New World Social Aid and Pleasure Club in 2006. (Photograph by Elena Serrano.)

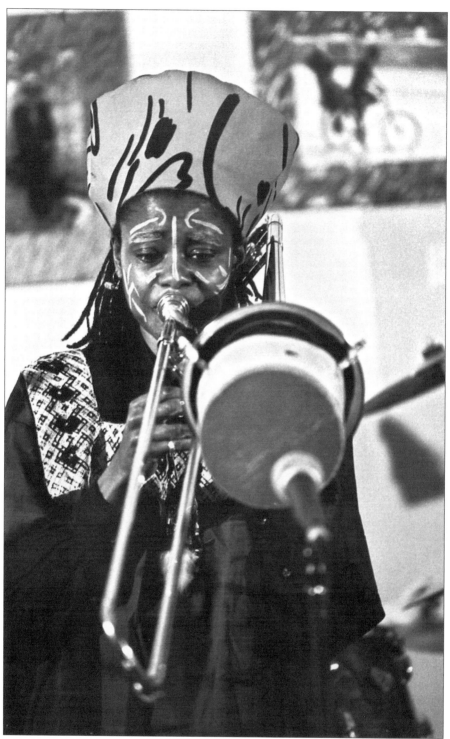

There was no stopping the brilliance of trombone player Angela Wellman, pictured here at Khafre's in Old Oakland. Wellman founded the Oakland Public Conservatory of Music on Franklin Street. (Photograph by Kamau Amen-Ra.)

The Malcolm X Jazz Festival brings together many well-respected musicians. This impromptu group photograph is, from left to right, (standing) Kwasi Cobie Harris, drummer Donald Green, saxophonist Howard Wiley, drummer Kahlil El Zabar, saxophonist Hamiet Bluiett, and violinist Billy Bang. Kneeling are unidentified and poet Umar Bin Hassen. (Photograph by Kamau Amen-Ra.)

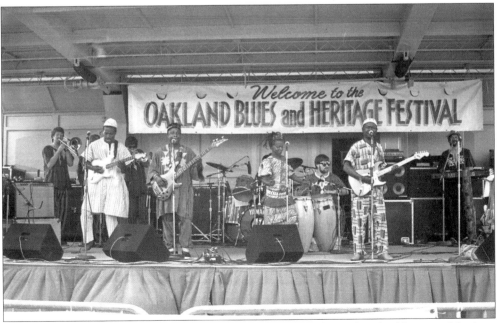

Pictured here during the First Oakland Blues and Heritage Festival is the Nigerian Afro-beat group Kotoja doing their thing. (Photograph by Kamau Amen-Ra.)

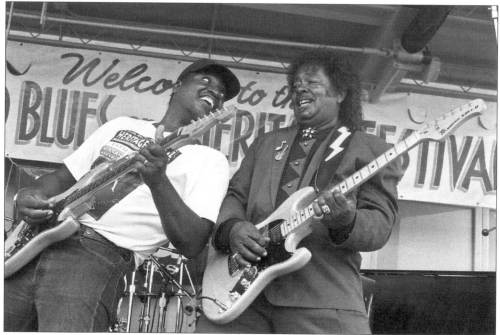

The Oakland Blues and Jazz Festival also featured these amazing musicians: Ronnie Stewart (left) and Guitar Shorty. (Photograph by Kamau Amen-Ra.)

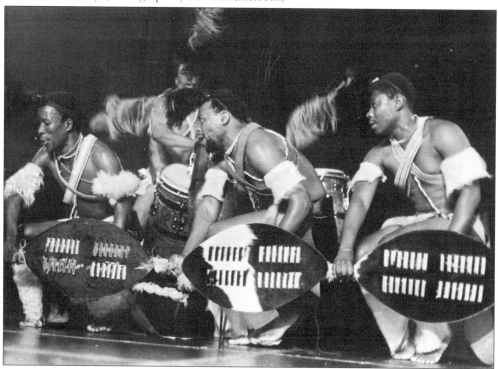

Seen here is the South African performing and musical group Zulu Spear. The front men for Zulu Spear were Sechaba Mokoena, Matome Somo, and Gideon Bendile. (Photograph by Kamau Amen-Ra.)

Young tenor saxophonist Howard Wiley has proven to be a forward-thinking musician in the tradition of the jazz innovators that precede him. He is the composer of the Angola Project, which focuses on the spirituals, work songs, and blues of the Louisiana State Penitentiary in Angola, Louisiana. This 1994 photograph was taken when Wiley was approximately 15 years old in the now-defunct Jack London Village complex in Oakland. (Photograph by Kamau Amen-Ra.)

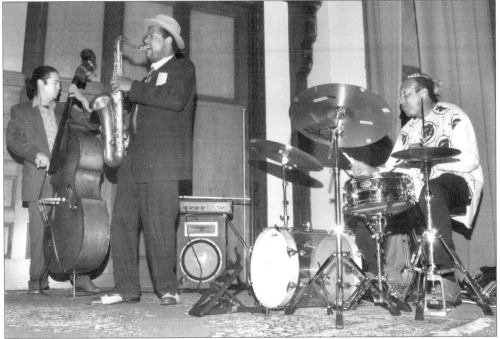

Pictured here again is Howard Wiley with E. W. Wainwright; they were performing together at the African American Museum and Library. This is what a jam session is all about. (Photograph by Kamau Amen-Ra.)

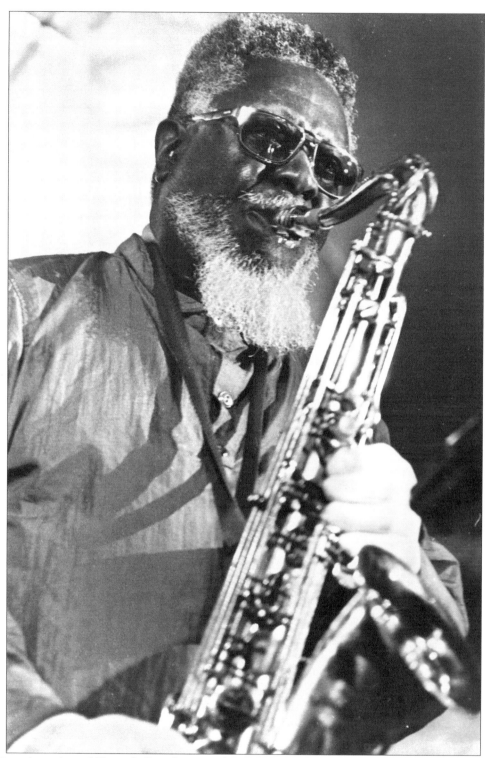

Saxophone legend Pharoah Saunders was also once an Oakland resident, often performing at and attending many of Oakland's music venues. (Photograph by Kamau Amen-Ra.)

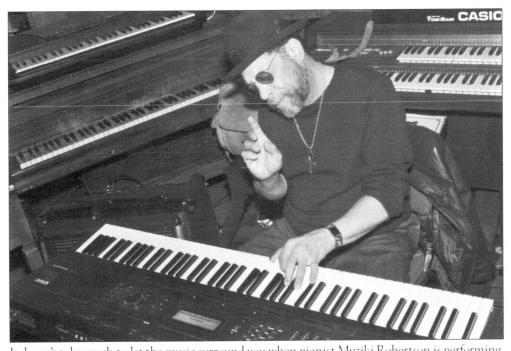

It doesn't take much to let the music surround you when pianist Muziki Robertson is performing. Robertson was the music director for the San Francisco Mime Troupe. (Photograph by Kamau Amen-Ra.)

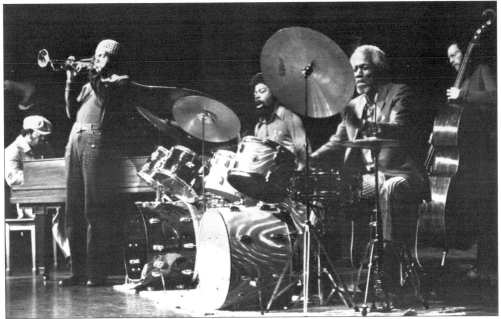

Two of Oakland's finest elder musicians are shown performing at the Keystone Korner in San Francisco in this rare mid-1970s photograph. Pictured from left to right are Ed Kelley (piano), unidentified (trumpet), unidentified (drums), Smiley Winters (drums), and unidentified (bass). Smiley Winters died in Oakland in 1994, and Ed Kelley died in 2005. (Photograph by Kathy Sloane.)

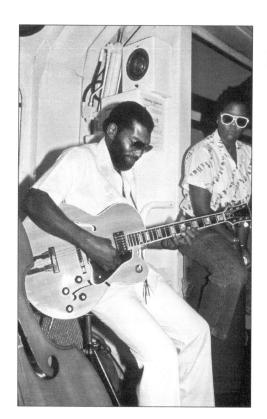

Pictured here is guitarist Calvin Keys performing with the Jazz on the Ferry series. (Photograph by Kamau Amen-Ra.)

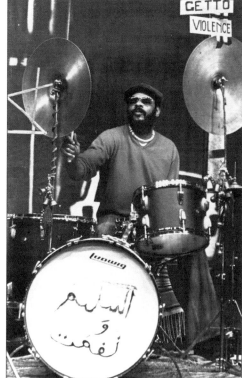

Jazz drummer Bob Braye was also an Oakland resident. This photograph from 1975 shows him performing for a play titled *Ghetto Violence*. He was a musical director for the play. (Photograph by Kathy Sloane.)

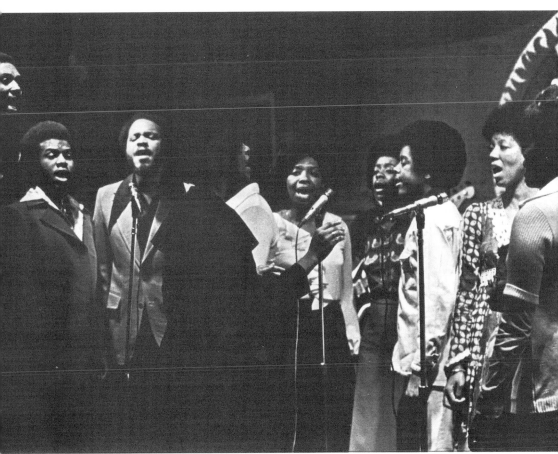

Pictured here are members of Faye Carroll's choir at the Keystone Korner in the 1970s. (Photograph by Kathy Sloane.)

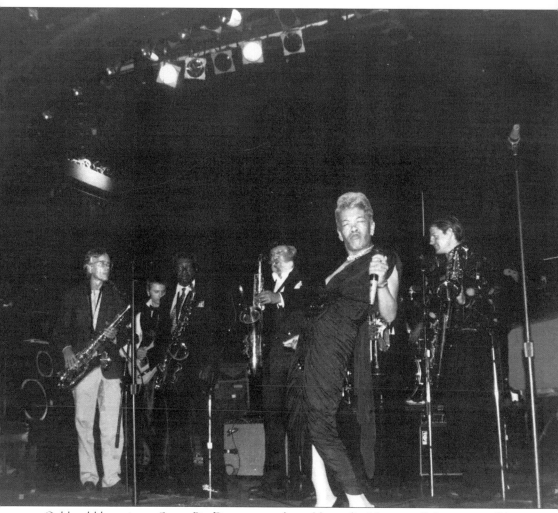

Oakland blues singer Sugar Pie Desanto was born Umpeylia Marsema Balinton to a Filipino father and African American mother in 1935. Having written songs with Oakland blues legend Bob Geddins and having been the opening act for James Brown in the 1960s, she is truly one of Oakland's blues legends and treasures. (Courtesy AAMLO.)

Destiny is affectionately known as "the harpist from the 'hood." She is a musician in the tradition of Dorothy Ashby and Alice Coltrane. Destiny is one of the many residents of the Malonga Casquelourd Center for the Arts building. This 1991 photograph was taken at a performance when the café that is now known as the Jahva House was known as Victor's Café. (Courtesy Kamau Amen-Ra.)

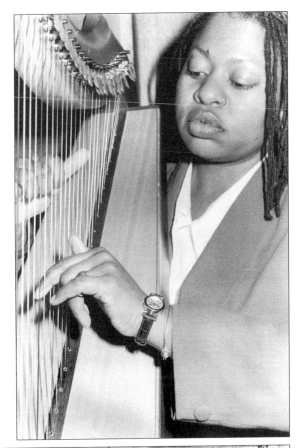

Pictured here is the jazz hip-hop group Mingus Amongus performing at Oakland's Festival at the Lake. The Festival at the Lake was an annual event held at Lake Merritt in the 1990s. (Photograph by Kamau Amen-Ra.)

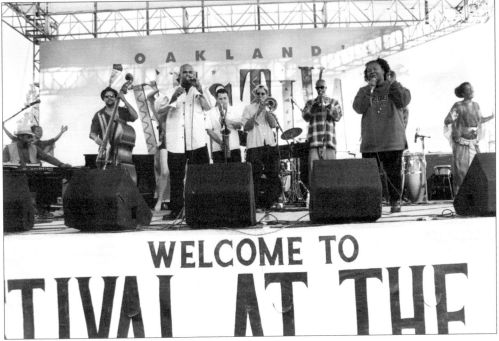

Oakland rap artist Saafir debuted in 1994 with his album *The Boxcar Sessions* and is known as a skilled freestyle rapper. He subsequently appeared in the film *Menace II Society*. (Photograph by Traci Bartalow.)

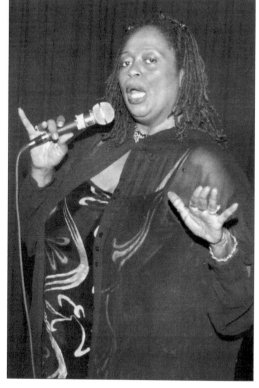

Pictured here is spoken-word artist and actress Ayodele "Word Slanga" Nzinga doing what she does best at one of the many West Oakland venues. The amazing talents of spoken-word/actress performers like Luisah Teish, Marajo, and Awelye Makeba have built a powerful scene that excites not only adult audiences, but also hundreds of schoolchildren and educational and artist non-profit organizations around Oakland. (Photograph by Kamau Amen-Ra.)

Experimental group Young People's Theater or Egypt Theater has been a transformative performing arts treasure in East Oakland since 1973. Founder and executive director Minnie Gibson stands in front of Egypt Theater's location on Foothill Boulevard. (Photograph by Duane Deterville.)

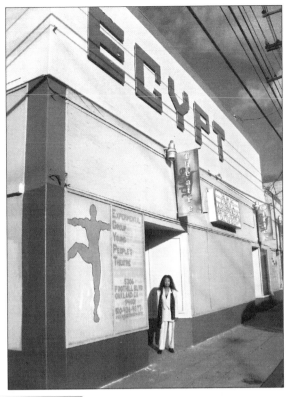

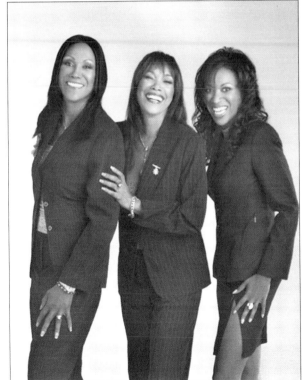

As seen in this most recent publicity shot of Oakland's own Pointer Sisters, they have taken the steps toward the future with the gleaming addition of granddaughter Issa to the always sensational and timeless singing legends. (Courtesy the Pointer Sisters Collection.)

Can we say "classic" or what? Pictured here are the original Oakland-born Pointer Sisters in a very early publicity shot, taken just before their career catapulted to the heights that led them to multiple Grammy Awards and platinum and gold albums. Pictured from left to right are Bonnie, Ruth, Anita, and June. (Courtesy the Pointer Sisters Collection.)

One of the first nationally popular women's groups in hip-hop, Oaktown 357, scored a big hit in 1989 with "Juicy Gotcha Krazy." Protégées of M. C. Hammer, they are shown here at their first video filming in San Francisco c. 1990. (Photograph by Mastahn Fanaka.)

Dancer, choreographer, photographer, poet, and journalist Traci Bartalow has left her mark on Oakland's hip-hop community in several artistic disciplines. Her work has been published in *Vibe*, *Source*, and *Rap Pages* in addition to several local publications. (Photograph by Kamau Amen-Ra.)

The platinum-selling singing group Enough often rehearsed in Oakland. The original quartet lived in Oakland before their national and international success. They are shown here accepting the keys to the city in front of Oakland's city hall. (Photograph by Kamau Amen-Ra.)

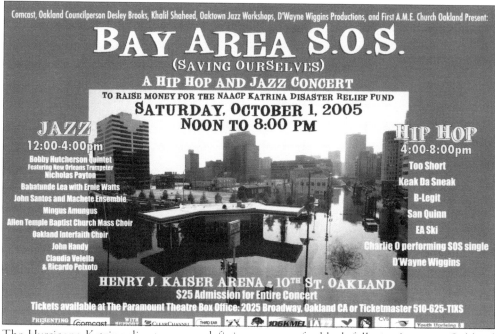

Comcast, Oakland Councilperson Desley Brooks, Khalil Shaheed, Oaktown Jazz Workshops, D'Wayne Wiggins Productions, and First A.M.E. Church Oakland Present:

BAY AREA S.O.S.
(SAVING OURSELVES)
A HIP HOP AND JAZZ CONCERT
TO RAISE MONEY FOR THE NAACP KATRINA DISASTER RELIEF FUND

SATURDAY, OCTOBER 1, 2005
NOON TO 8:00 PM

JAZZ
12:00-4:00pm
Bobby Hutcherson Quintet
Featuring New Orleans Trumpeter
Nicholas Payton
Babatunde Lea with Ernie Watts
John Santos and Machete Ensemble
Mingus Amungus
Allen Temple Baptist Church Mass Choir
Oakland Interfaith Choir
John Handy
Claudia Velella
& Ricardo Peixoto

HIP HOP
4:00-8:00pm
Too Short
Keak Da Sneak
B-Legit
San Quinn
EA Ski
Charlie O performing SOS single
D'Wayne Wiggins

HENRY J. KAISER ARENA = 10TH ST. OAKLAND
$25 Admission for Entire Concert
Tickets available at The Paramount Theatre Box Office: 2025 Broadway, Oakland CA or Ticketmaster 510-625-TIXS

PRESENTING Comcast WITH SUPPORT ClearChannel THIRD EAR 106KMEL Youth Uprising

The Hurricane Katrina disaster was a defining moment for black folks in America. Oakland hosted many of the victims of this devastating event and held events to raise money for relief efforts. The event seen here featured the performances of legendary jazz musicians John Handy, Bobby Hutcherson, Ernie Watts, and Babatunde Lea, along with hip-hop performers Too Short and Keak Da Sneak. World-renowned Oakland musician Dwayne Wiggins performed in addition to helping organize the event.

Longtime photographer Kamau Amen-Ra is pictured with Oakland's song stylist La Toy London, an *American Idol* finalist, enjoying the festivities at a recent Art and Soul Festival. This festival joins everyone in the arts community, which fosters the essence of a city built on spirit.

Afterword

Black Artists in Oakland is an overview, an introduction to the African diasporic crossroads that is the black arts community in Oakland. This small number of pages cannot contain a comprehensive survey of such a vast and rapidly growing community.

Black Artists in Oakland endeavors, whenever possible, to focus on the elder artists and grassroots artists of the community. The intention of this overview was to pay homage to some individuals that are less known outside the community but have legendary status within it. Oftentimes we ignore greatness in our backyard until someone outside of the community recognizes it, so we want to bring to the fore significant figures that have created world-class art but haven't achieved the household name status of the Pointer Sisters, Toni Tony Tone, and Tupac Shakur.

We also want to document those public places that serve as a showcase for creative talent. The newer black-owned gallery spaces are the Joyce Gordon Gallery, Stoneridge Gallery, and the Thelma Harris Gallery. All three showcase emerging and established artists. In addition to these, there is the work of the Soul Salon Ten, a group of black visual artists who have mounted extraordinary group shows in both established and alternative art spaces.

As of this writing, the contemporary black art scene in Oakland is witnessing the reemergence of a black arts community in West Oakland, even in the face of the threat of rapid gentrification. The work of poet/rapper and real estate entrepreneur Marcel Diallo, with his Black New World Social Aid and Pleasure Club on Pine Street in West Oakland, has been particularly dynamic. He has hosted some of the Mardi Gras black Indians that are now residents of Oakland as a result of displacement from the Katrina disaster, as well as world-renowned jazz musicians and poets. His work represents the oftentimes-overlooked community-building contributions of Oakland's hip-hop community.

Oakland is known for having produced seminal rap artists Too Short, Hammer, Digital Underground, and The Coup. The most talked about scene in hip-hop culture at the moment is "Hyphy" (Hyper/Fly); an East Oakland style of black vernacular music and dance that has gained national attention for its valorization of drug culture and sometimes undisciplined behavior. However, the work of organizations such as Youth Movement Records that uses hip-hop as a tool for education and the development of critical-thinking skills goes underreported. The same for Oakland rap artist/educator Naru Kwina, who has for several years produced hip-hop CDs that he calls "hip science" to teach children science lessons using rap and rhyme.

Beyond its grassroots hip-hop community, Oakland, Oaktown, or "the Town," as it's currently called by the hip-hoppers, is most impressive as an African diasporic crossroads and destination point for performing artists. Musicians Omar Sosa from Cuba, Sooliman Rogie from Sierra Leone, and the late, great Nubian oud master Hamza El Din from Sudan all have been residents of Oakland. The Malonga Casquelord Center for the Arts is known for hosting master drummers and dancers, both as artists in residence and as guests. In 2005, Sankofa Cultural Center, in conjunction with Mission Alliance for Students of the Arts, hosted Vovo Antonio Carlos dos Santos, the founder of Ile Aiye. Ile Aiye is a cultural arts organization in Brazil that was a catalyst for the black consciousness movement in Brazil. When Vovo arrived here, he said that the style, music, and culture of black Oakland in the 1970s was influential to the cultural awakening of his generation of black Brazilians. Vovo's statement is a testimony to the far-reaching affect of Oakland's black arts community. In 2007, as Oakland welcomes new mayor Ron Dellums and his ambitions to bring a much higher profile to the arts communities, Oakland's black arts community anticipates an even more profoundly far-reaching voice in the African diaspora.

—Duane Deterville

BIBLIOGRAPHY

Beckford, Ruth. Interviewer: Penny Peak. Penny Peak and Jeff Freidman, eds. *Legacy Ruth Beckford: Oral History of Ruth Beckford*. San Francisco, CA: San Francisco Performing Arts Library and Museum. Limited edition for institutional archives only. June 1995.

Goggins, Jim, and Earl Watkins. *The Life of a Jazz Drummer*. Victoria, BC: Trafford Publishing, 2006.

Lewis, Samella, and Ruth Waddy. *Black Artists on Art, Vol I*. Los Angeles, CA: Contemporary Crafts, Inc., 1969.

———. *Black Artists on Art, Vol. II*. Los Angeles, CA: Contemporary Crafts, Inc., 1971.

Poindexter, Norwood "Pony." *The Pony Express: Memoirs of a Jazz Musician*. Frankfurt, Germany: JAS Publikationen, 1985.

Stoddard, Tom. *Jazz on the Barbary Coast*. Berkeley, CA: Heyday Books, published jointly with the California Historical Society and the San Francisco Traditional Jazz Foundation, 1998.

Vignes, Michelle, and Lee Hildebrand. *Bay Area Blues*. Rohnert Park, CA: Pomegranate Art Books, 1993.

Wolfe, Rinna Evelyn. *The Calvin Simmons Story or "Don't Call Me Maestro."* Berkeley, CA: Muse Wood Press, 1994.

INDEX

Adisa, Opal Palmer 64
Angelou, Maya 61
Banjo, Casper 77–79
Batamuntu, Ghasem 40, 44, 49, 69
Beckford, Ruth 26
Bradford, David 34, 85
Brown, Karen "KB" 98
Clark, Claude Sr. 31–33
Clark, Claude Jr. 31–33
Colescott, Robert 88
Cooke, India 43, 46, 68
Eli's Mile High Club 24
Esther's Orbit Room 22, 23
Etterick, Melvin 85
Fabulous Ballads, the 28
Handy, John 47, 124
Desanto, Sugar Pie 118
Hines, Earl "Fatha" 13–15
Jenkins, Slim 17–20
Jiltonilro, Avotcja 50
Johnson, Woody 73, 85, 89
Johnson, Guy 61
Johnson-Calloway, Marie 77
Kelley, Ed 48, 51, 115
Keys, Calvin 42, 116
Koncepts Cultural Gallery 65, 67–70
Kujichagulia, Phavia 36, 37
Lange, Jerri 94
Lasha, Prince 70
Lewis, Tarika 46
Lockett, Reginald 54, 58, 85, 104
Malonga Casquelourd Center 100, 101, 103
Matthews, Edsel 65
Monroe, Arthur 85, 87
Morgan, Michael 97
Muse, Daphne 93
Mwongozi, Rudi 104
Pontiflet, Ted 90, 91

Powell, Pauline 10, 46
Riggs, Marlon 57
Saunders, Raymond 86, 90
Siddik, Rasul 38, 39
Simmons, Calvin 96
Starr, Henry 12, 13
Thomas, Oluyemi and Ijeoma 41
Turner, Morrie 29, 30, 92, 93
Wainwright, E. W. 35, 36, 43, 113
Sosa, Omar 106
Watkins, Earl 13, 14, 20
White, Arnold 91, 92
White, Michael 47
X, Marvin (El Muhajir) 62, 63

Discover Thousands of Local History Books
Featuring Millions of Vintage Images

Arcadia Publishing, the leading local history publisher in the United States, is committed to making history accessible and meaningful through publishing books that celebrate and preserve the heritage of America's people and places.

Find more books like this at
www.arcadiapublishing.com

Search for your hometown history, your old stomping grounds, and even your favorite sports team.

Consistent with our mission to preserve history on a local level, this book was printed in South Carolina on American-made paper and manufactured entirely in the United States. Products carrying the accredited Forest Stewardship Council (FSC) label are printed on 100 percent FSC-certified paper.

MADE IN THE
USA